PRE-RAPHAELITE GIRL GANG

PRE-RAPHAELITE GIRL GANG

Fifty Makers, Shakers and Heartbreakers from the Victorian Era

KIRSTY STONELL WALKER

illustrations by Kingsley Nebechi

UNICORN

Acknowledgements

I'd like to thank the wonderful team at Unicorn – Lucy, Felicity, Ramona, Louise and Ian – for being so marvellous and a pleasure to work with on such a fun book.

Eternal gratitude goes to Esther Harris at Bookollective for being the Susie to my Mrs Maisel, without whom there would have been less cake and much less red lipstick.

As always I would not be able to do anything without the support of Miss Holman, Ms Graham-Piña, the ever-patient Mr Walker and the beauteous Lily-Rose.

Contents

Introduction

Welcome to *Pre-Raphaelite Girl Gang*, a roll-call of fifty women who had a part in shaping what we understand by the term 'Pre-Raphaelite'. They might be artists, photographers, models, sisters, wives, girlfriends or any combination of those things, but each of them has contributed to the momentum of the movement which has found renewed popularity in our modern world. I have placed them in chronological order, so not to show favouritism, but also to show interesting contemporaries; laundress Ellen Smith and artist Marie Spartali Stillman were both born in 1844, yet their lives show the wide span of the women in this book – one born to comfort and privilege and one, well, no spoilers, but decidedly not.

BEFORE WE GET INTO ALL THAT, WHAT DO WE MEAN BY PRE-RAPHAELITE?

The Pre-Raphaelite Brotherhood was founded in 1848 by three young painters, William Holman Hunt, John Everett Millais and Dante Gabriel Rossetti, who were joined by William Michael Rossetti (writer, critic, editor and brother of Dante Gabriel), Frederic George Stephens (painter then writer), Thomas Woolner (sculptor), and James Collinson (painter). Fuelled by the writing of John Ruskin, the Brothers determined that they would paint directly from nature, depicting real people in real places even if the work was inspired by fiction or poetry. They rejected the work of painters before them, all the way back to Raphael (hence *Pre*-Raphaelite), who, in their opinion, had done a disservice to art by painting by rote, corrupted by the 'academic' teaching style of art schools. Founder of the Royal Academy, Sir Joshua Reynolds, came in for particular criticism, nicknamed by the Brotherhood 'Sir Sloshua' and the Brothers agreed to keep their group secret from the Academy when exhibiting, but Millais couldn't resist slipping the initials 'PRB' into his painting *Isabella* (1848-9).

The Brothers new style of art was not immediately popular. Critics such as Charles Dickens were horrified at the recognisably ordinary people used to portray the Holy family, and others were put off by the level

of minute detail in the depiction of nature. Riding to their defence came John Ruskin, art critic and the man whose writings had inspired the Brothers in the first place. With his promotion of their work, Millais, Rossetti and Holman Hunt's art slowly gained in popularity. However, broken marriages, scandal and Rossetti's inability to leave other people's girlfriends alone all led to the breaking down of the close relationship of the group by the end of the 1850s. But by that time a second wave of painters had become inspired by the Brotherhood. William Morris and Edward Burne-Jones had become acolytes of Rossetti and already established artists such as George Frederic Watts and Ford Madox Brown became associated with the movement in subjects, tone and relationships. Each generation brought forward more, increasingly female artists, who each found inspiration in nature, literature and poetry, adding their own vision to Pre-Raphaelitism, well into the twentieth century.

Please note, this is *my* list of fifty Pre-Raphaelite women, and you are free to disagree, or indeed add more. Certainly, there are dozens of models of whom we know nothing, not even a name, and artists who have slipped from our view, but it is up to us to find them and celebrate them as most of them were unable to celebrate themselves. I hope the following inspires you to find out more.

Opposite – *Mariana*
John Everett Millais, 1851

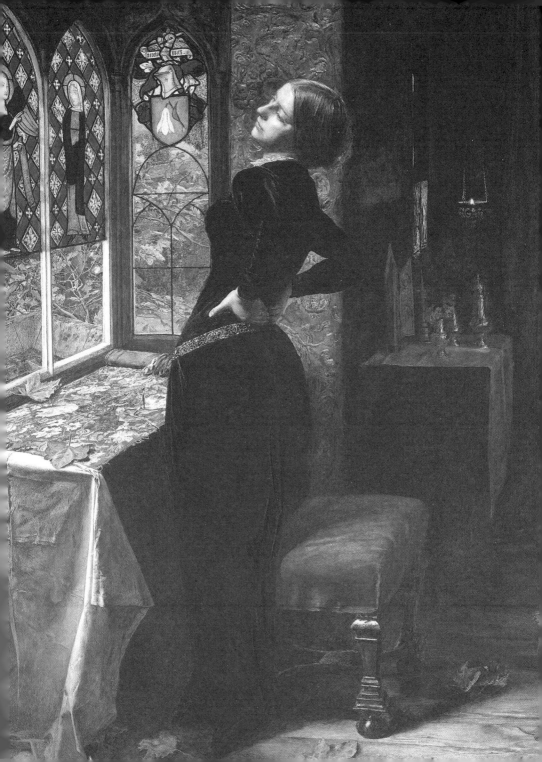

Julia Margaret Cameron
1815-1879

On her forty-eighth birthday, Julia Margaret Cameron's daughter gave her an unusual present. Julia was passionately interested in photography and was given a large box camera to take her own glass-plate images. Her children had grown up, and Julia needed something practical and creative to fill her time. With photography she not only found a hobby, she found a career in which she would be a pioneer.

It was not the first time Julia had used a camera. She had been assisting other photographers such as Oscar Rejlander for a few years and had been learning from her experiences; however, this was the first time she would have complete control over the whole process. From her home on the Isle of Wight, Julia produced not only imaginative portraits of famous artists, writers and scientists, but also created works of art using her maids and local people as models. Her photographs, often based on biblical or poetic subjects, drew on Pre-Raphaelite images, including beautiful, strong women with long, flowing hair.

Although she was best known for her portraits of men such as Alfred, Lord Tennyson and Charles Darwin, her photographs of women were imaginative and unconventional.

Vivien and Merlin
Julia Margaret Cameron, 1874

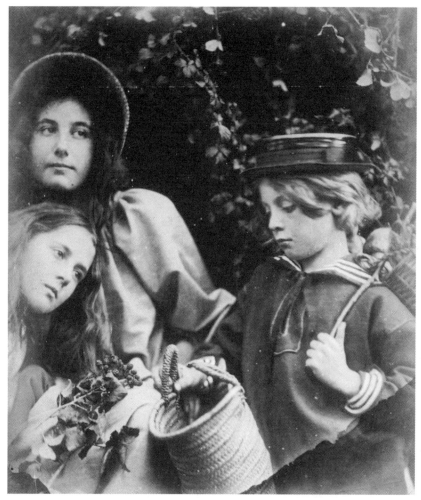

Blackberry Gathering
Julia Margaret Cameron, c.1868-70

She even used female models
to represent male saints, and she
deliberately blurred the focus and
scratched decorative details directly
onto the negatives. Her unorthodox
methods meant she found more

acceptance among artists such as
George Frederic Watts than among
fellow photographers. Lewis Carroll,
a friend of Julia's, often criticised
her 'out of focus' images which
went against what he believed was

the purpose of photography – to reproduce life as clearly as possible.

Julia also enjoyed a close friendship with Tennyson, the Poet Laureate and her neighbour on the Isle of Wight. His poetry provided the inspiration for many of her images and together they produced an edition of his poetry illustrated by large-scale photographs inspired by his verse. In turn, her personal and intimate images of the Poet Laureate showed Tennyson as he really was, complete with his tangled beard.

Julia wasn't only an artist, she also used her photography to earn money for the family, and was a shrewd business woman. She copyrighted her photographs, which meant only

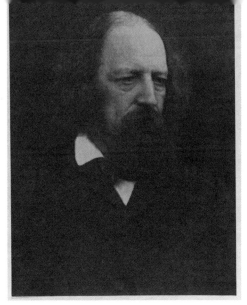

Alfred, Lord Tennyson
Julia Margaret Cameron, 1866

she could sell the images and she managed to support her family while their coffee plantations in Ceylon were not thriving. In 1875, the couple left Freshwater for Ceylon for good, where Julia continued to take photographs of the workers on their estate and visitors who came to the plantation, such as the painter Marianne North. She died there only four years later. She had only been a photographer for just over a decade but her influence and impact remains as strong today as it was in her lifetime, partly due to the women in her family. Her niece, Julia Jackson, wrote her entry in the *Dictionary of National Biography* and in the 1920s, her great-niece, Virginia Woolf, produced a book of Julia's photographs, introducing them to a whole new generation.

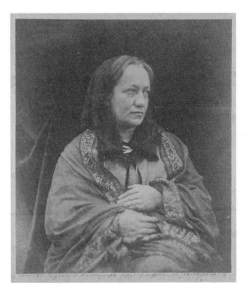

Julia Margaret Cameron
Henry Herschel Hay Cameron, 1870

13

MARY HODGKINSON

When John Everett Millais was looking for one of his first models, he didn't look too far outside the family. His mother had been widowed and Millais had a stepbrother, Henry Hodgkinson, a chemist who set up shop in Kensington, London. Henry was engaged to Mary Ann Coward, who was the stepdaughter of Henry's stepmother's sister, which was far too complicated to worry about, and when Millais was looking for demure young women to model for his canvas *Isabella* in 1848–9, he found the perfect model in Mary.

The whole of *Isabella* is filled with Millais' friends and family. Mary was seated next to William Michael Rossetti, who is pictured handing her some very symbolic fruit. Dante Gabriel Rossetti is seen at the end of the table drinking wine, opposite fellow Pre-Raphaelite friends Walter Deverell and Frederic Stephens. Millais' father is the older man wiping his mouth. In her very contained movement and quiet stillness, the figure of Isabella is at total odds to all the men in the painting, and it was that same

gentleness that Millais called upon when looking for a model for the Virgin Mary in his follow-up canvas, *Christ in the House of his Parents* (1849–50). As it turned out, this would be the last canvas for which Mary would model, possibly due to the rather unkind review by Charles Dickens in *Household Words* of June 1850: '… a hideous, wry-necked, blubbering, red-haired boy in a nightgown, who appears to have received a poke playing in an adjacent gutter, and to be holding it up for the contemplation of a kneeling woman, so horrible in her ugliness that (supposing it were possible for any human creature to exist for a moment with that dislocated throat) she would stand out from the rest of the company as a monster in the vilest cabaret in France or in the lowest gin-shop in England'.

The models of the Pre-Raphaelite movement often found themselves the subject of slurs but being labelled a 'monster' in the 'lowest gin-shop in England' takes some beating, and it is therefore unsurprising that Mary

quit her life of modelling to return to her rather more comfortable and less insulted life as the wife of a wealthy chemist in Kensington. In the meantime, supported first by the defence of art critic John Ruskin but then by his sheer talent, Millais went on to be one of Britain's best known and rather wealthy painters, graciously not only burying the hatchet with Dickens over the 'vilest cabaret' business but actually becoming friends. In an interview in 1923 with Mrs George Wright, former cook to Henry Hodgkinson, she recalled Dickens coming to dinner with Millais and his step-brother. 'I used to cook him a perfectly plain dinner – just soup, fish, generally a chicken, and sweets,' recalled Mrs Wright, although she failed to mention whether Mary Hodgkinson was ever left alone with Mr Dickens's food before he ate it....

Mary died a wealthy old lady at the age of seventy-nine, hopefully with the comforting secret that she once deliberately sneezed into Charles Dickens's crème brûlée.

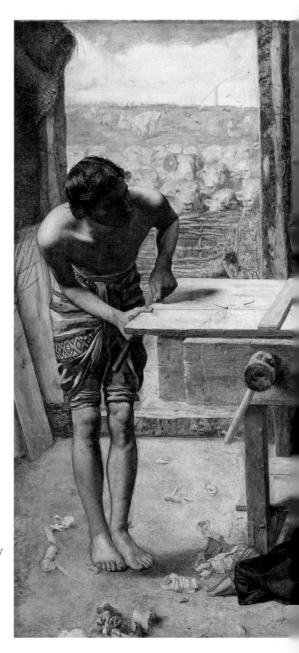

Christ in the House of his Parents
John Everett Millais, 1850

Overleaf – *Isabella*
John Everett Millais, 1849

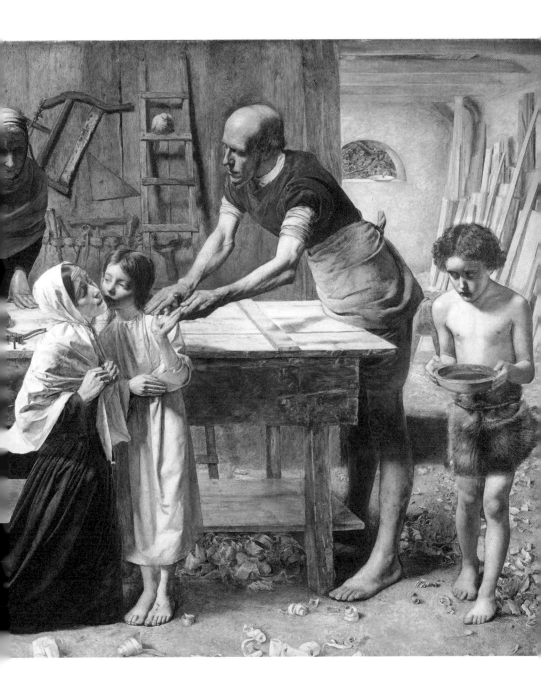

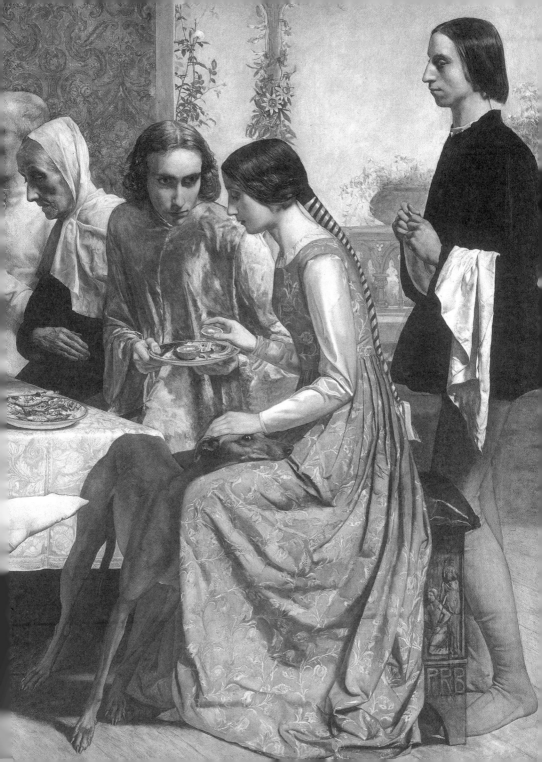

EUPHEMIA GRAY

1828–1897

A decade before Euphemia Gray, or 'Effie' as she was known to her family, came into the world, John Ruskin's grandfather cut his own throat. This maudlin fact might seem unconnected, but his death meant his house, Bowerswell, was let to the Gray family. Mr and Mrs Gray knew the Ruskins, and encouraged a match between John Ruskin and little Effie, even though there was a nine-year age gap between the pair. When Effie was twelve, Ruskin wrote her a fairy story which delighted her. Sadly, that was probably the last time he did delight her....

He waited until she was twenty before proposing marriage, unsure whether or not a wife was necessary for his studies. Ruskin was extremely clever and devoted to his writing and art, for which he was well known and, more to the point in the case of Effie's family, well paid. The marriage went ahead but allegedly the problems started almost immediately. Ruskin and Effie made an agreement that they would abstain from sex for five years so that children wouldn't disrupt his work, but it is unlikely that Effie would have had very

much say in the matter. The abortive wedding night, with Ruskin fleeing at the atrocious sight of his nubile young wife's lovely body is now a matter of legend. Various reasons have been ascribed to his actions, including fear of pubic hair and homosexuality, but in truth neither of them were entirely forthcoming on the disasters of their marriage and probably neither fully understood what had gone wrong.

The couple spent time in Italy after their marriage, which relieved the pressure of Ruskin's parents, who were ever-present in his life, with no respect for the position of his wife. However, it further highlighted the difference in their characters and how unsuitable the couple were for each other. Ruskin drew ancient buildings and immersed himself in art, whilst Effie attended parties and indulged in discrete flirtations.

On their return to England, Ruskin became involved with championing a new band of young artists, calling themselves the Pre-Raphaelites. In particular, Ruskin felt the work of John Everett Millais to be the

Euphemia 'Effie' Chalmers Gray, Mrs John Ruskin (1828-1898), later Lady Millais, with Foxgloves in her Hair (The Foxglove)
John Everett Millais, 1853

pinnacle of his own views on art. He invited Millais to paint his portrait in a suitably striking location, Glenfinlas in Scotland, taking the young artist and Effie with him. Millais found Effie utterly beguiling, and the couple fell in love. Ruskin insisted that Millais use Effie as model for *The Order of Release 1746* (1852–3) and the rift between Effie and her husband deepened as she grew closer to Millais. After bitter

arguments with her husband and his parents, Effie sought refuge back in Scotland with her parents and filed for an annulment on the grounds of non-consummation. After six years of marriage, Effie cited incurable impotence in her husband as her grounds for freedom. The courts insisted on physically examining her and found her to still be a virgin. Effie was granted her annulment and she was free to marry Millais. Later in life, the parents of Rose La Touche, a young girl tutored by Ruskin, wrote asking Effie's advice, as Ruskin had proposed marriage to Rose.

What Effie wrote in her reply was so effective that Mr and Mrs La Touche immediately removed their daughter from Ruskin's company and never spoke to him again.

By contrast, the Millais marriage was long, happy and blessed with many children. The scandal of her annulment however meant that Effie was banned from attending any event that Queen Victoria would also be attending. This bothered the Millais greatly, as Effie loved to socialise, especially with the growing status of her artist-husband, and many of her friends acknowledged how wrong it was to punish Effie for the failings of the marriage. Queen Victoria relented and granted Effie her social freedom when Millais was dying, as a favour to him. Effie died sixteen months after her husband, aged sixty-nine, and is buried in a Perthshire graveyard depicted in his painting *The Vale of Rest* (1858–9).

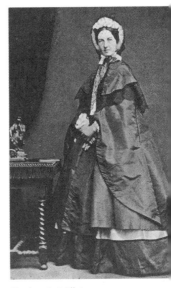

Euphemia Millais
Unknown, n.d.

The Order of Release 1746
John Everrett Millais, 1852-3

ELIZABETH SIDDAL

1829 - 1862

If you ask anyone to name one thing that defines a Pre-Raphaelite woman, probably top of the list would be red hair and we have Elizabeth Siddal to thank for that. With her cascade of copper tresses, Elizabeth, or 'Lizzie' as she was known, was the feminine ideal for one of the Pre-Raphaelite brothers whilst becoming iconic through the work of another, but she was not beautiful in a traditional Victorian way. In a time when small, plump, dark-haired women were seen as the pinnacle of womanhood, a thin, pale, red-headed girl with large eyes was not considered attractive. Through her work with the Pre-Raphaelites, Lizzie changed all that.

Her father had pretentions to greatness. The Siddal family had apparently been cheated out of their fortune and position, and Mr Siddal doggedly tried to prove their claim to nobility, without any success. After finding a poem by Tennyson written on the paper that wrapped a butter pat, Lizzie started writing her own verses, hiding them from her family. Like many of the models, Lizzie was a working girl, sewing in a milliners, when she was discovered. Walter Deverell, brief-lived associate of the Pre-Raphaelite Brotherhood, saw her whilst shopping with his mother and persuaded her to pose for him. The presence of his mother and sister made this safe and almost respectable. However, also modelling in Deverell's *Twelfth Night* (around 1850) sitting opposite Lizzie, literally playing the fool, was Dante Gabriel Rossetti. He fell in love with her, but she wasn't easily won over. She modelled next for John Everett Millais in arguably her best-known role.

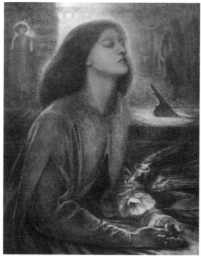

Beata Beatrix
Dante Gabriel Rossetti, c.1864-70

Overleaf – *Ophelia*
John Everett Millais, c.1851-2

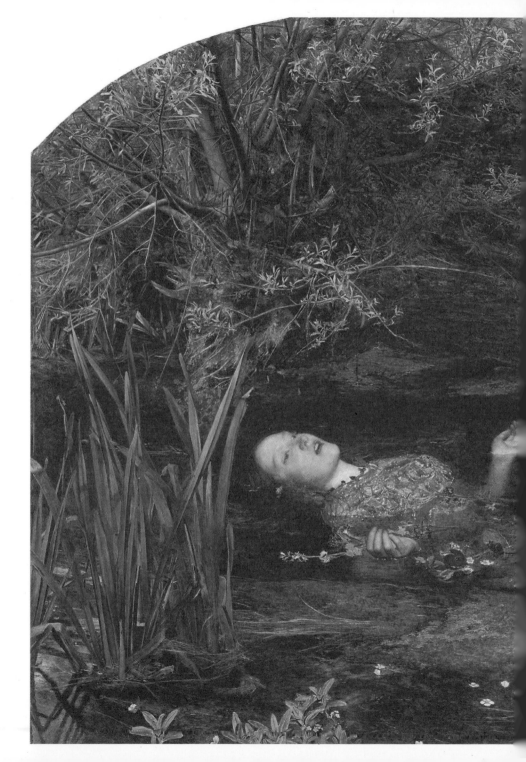

Sketches
Dante Gabriel Rossetti, 1850s

There are a few moments in Lizzie's life that have become almost legendary. One of these has to be the story surrounding her experience in posing for Millais' *Ophelia* (1852). Millais had painted the riverbank and river – where the poor, mad Ophelia drowns – whilst on location in Surrey and just needed to put a floating figure in, posed in a studio. Lizzie reclined in a bathtub wearing a silver embroidered second-hand dress while lots of little candles warmed the tub. Slowly, as the hours ticked by the candles fizzled out but Millais, engrossed in his work, didn't notice and the slowly freezing Lizzie did not want to disturb him. Finally, when the poor girl started turning blue, the artist finally noticed and hauled his unfortunate model out but too late as Lizzie had developed pneumonia, the recovery from which probably resulted in her addiction to laudanum. Her parents were unwilling to let their daughter pose for Millais again, but somehow the peril of fellow-artist Dante Gabriel Rossetti went unnoticed, and one of the great love affairs of the Pre-Raphaelite circle began.

Rossetti was as fickle as he was passionate and although he obsessively drew his beloved 'Guggums', this did not prevent his eyes from constantly wandering. He set up home with Lizzie on the promise of an engagement when finances would allow but did not stop chasing other women, including Annie Miller, Fanny Cornforth and Ruth Herbert, and no doubt others. Lizzie took solace in her poetry and her painting, which Rossetti taught her between bouts of infidelity, and her art began to take its place in exhibitions both in this country and America.

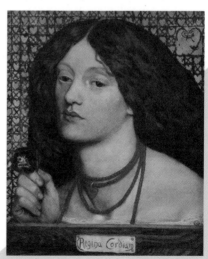

Regina Cordium
Dante Gabriel Rossetti, 1860

Unfortunately, her increasing dependence on opiates damaged her health. Rossetti was summoned to her supposed deathbed and proposed a swift marriage, obviously believing that she would die, but not only did Lizzie make it down the aisle, she rallied in health, now respectably 'Mrs Rossetti'. Her husband denounced all other women for almost six months but slowly and surely his eyes wandered and Lizzie returned to her laudanum, which not only irreparably destroyed her own health but caused miscarriages. Finally, pregnant once more but filled with dread and anxiety, Lizzie took an overdose and died at the age of thirty-two. Rumours existed that she had committed suicide and left a note that either read 'Take care of Harry' (her younger brother) or rather more dramatically, 'My life is so miserable I wish for no more of it', but as suicide would have meant that she could not have received a Christian burial, no mention of a note was ever officially made. Rossetti was struck by an overwhelming grief and guilt from which he never really recovered, and placed his manuscript of poems in the coffin, wrapped in his beloved Lizzie's red hair.

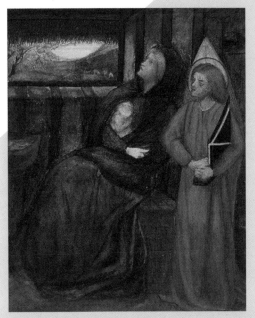

Holy Family
Elizabeth Siddal, c.1856

Seven years later, Rossetti allowed the grave to be disturbed and the coffin opened in order to retrieve the manuscript for publication. When he asked one of the grave diggers what they had seen in the coffin, he was told Lizzie looked as if she was asleep, perfectly preserved, with her copper hair now filling the coffin. When he received the manuscript back after disinfection, there was a hank of hair still trapped between the pages and a large wormhole right through the middle. Rossetti swore never to be buried beside his wife at Highgate Cemetery because he was terrified she would crawl into his coffin and exact her revenge, and who could blame her?

Emma
Madox Brown

When the author Ford Madox Ford came to write about his grandmother, Pre-Raphaelite muse Emma Madox Brown (née Hill), he performed a little subterfuge in order to make the circumstances of her marriage respectable. By his account, Emma and Ford Madox Brown had met, fallen in love and married far before the arrival of their first daughter Cathy, but actually the family had lived together secretly for years without the benefit of wedlock.

Emma Matilda Hill had started modelling in order to support her mother. Her father had moved the family to London in search of work as a bricklayer but had promptly died, leaving the Hills struggling. Emma's pretty face was set to work at the studio of Ford Madox Brown, a friend and teacher of Dante Gabriel Rossetti, but a little older than the young rebellious artists of the Pre-Raphaelite movement. He

Portrait of Emma Madox Brown
Ford Madox Brown, 1853

had been recently widowed and left with a young daughter, Lucy, and in no mood for romantic young women, but something about Emma charmed him. In his diary Brown wrote he had intended to work all day but 'a girl as loves me came in and disturbed me'. It became quickly obvious that Brown didn't mind being disturbed at all.

Mrs Hill was not keen on her daughter's romantic entanglement with Brown. Obviously, in her mind the daughter of a bricklayer was meant for better things than an established artist, but Emma settled the matter by giving birth to the couple's first child, Cathy, in 1850. Emma and Brown set up home together in secret and when Brown's paintings did not sell, Emma went out to work as a maid to keep the family together. She also posed for paintings for hours as Brown worked slowly in his meticulous Pre-Raphaelite style. The ribbon on Emma's bonnet in *The Last of England* (1864–6) took a month and he made her pose outside for so longer whilst painting *Pretty Baa Lambs* (1851–9) that she was badly sunburnt.

The Browns married in 1853 and sons Oliver and Arthur were born to the happy couple. Brown planned a celebratory portrait of his wife

Cinderella
Ford Madox Brown, n.d.

holding baby Arthur aloft to a delighted father, entitled *Take Your Son, Sir!* (begun 1851) but when Arthur suddenly died the painting was abandoned, the beautiful baby the only complete aspect of an otherwise ghostly vision. Arthur's death may have contributed to Brown's depression and Emma's drinking. Recorded in Brown's diary

Opposite – *Thinking*
Ford Madox Brown, 1869

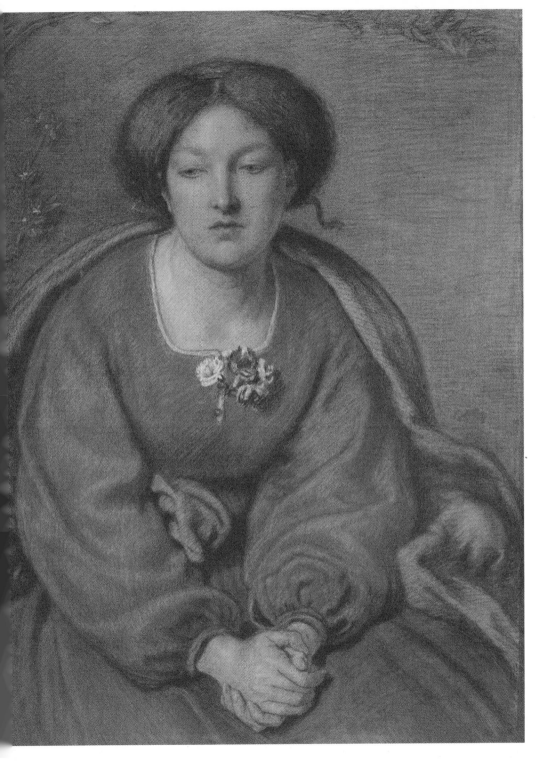

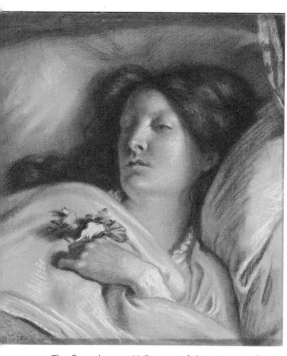

The Convalescent (A Portrait of the Artist's Wife)
Ford Madox Brown, 1872

a small posy of pansies, and recorded that 'Now she is lying in bed thinned with fever she looks very pictorial and young as ever again.' Ironically, it was this picture that Brown used after Emma's death to illustrate a book by his mistress.

Brown worked for many years on frescos in the Town Hall in Manchester, and it was after making the journey whilst unwell that Emma died. In her obituary it was noted that her husband had only just finished a painting of her, 'Stages of Cruelty' which had been started thirty four years previously and shows the young, beautiful Emma grinning mischievously out at us while her tormented lover struggles for her attention.

Cathy Madox Brown became a Pre-Raphaelite painter in her own right, and Lucy, Brown's daughter by his first marriage, married Rossetti's brother, William Michael, ensuring that the family would be entwined with Pre-Raphaelitism forever.

are instances of her behaviour whilst under the influence, an obvious cause for anxiety and embarrassment, but he doesn't seem to have had the self-awareness to consider the impact of his own actions. Brown fell in love and conducted affairs with other women, including writer Matilda Blind, who Brown moved into the family home. He employed a woman to keep guard on Emma to control her drinking and subsequent actions. A truce was called on the eve of their daughter's marriage when Emma became dangerously ill. Brown drew Emma in bed holding

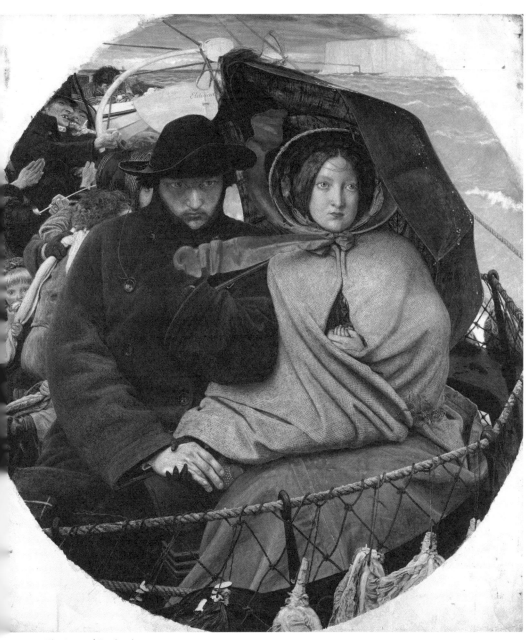

The Last of England
Ford Madox Brown, 1855

Anna Blunden
1829-1915

The daughter of Quaker bookbinders who moved to Exeter when she was a baby, Anna Blunden's family business changed when she was young to making straw hats and silk flowers. Running a business seems to have been a Blunden family trait, as Anna and her sister Emily ran their own for a while, dealing in wool, but that did not save her from training for that most hated of Victorian professions, the governess. During her studies, however, she felt that her real calling was artistic. She read John Ruskin's books on art, falling in love with both the subject and the author, and ran away to London to become an artist. She attended Leigh's Academy, but also studied independently in the National Gallery and the British Museum. She started to exhibit her work in her early twenties, catching the eye of her hero, Ruskin, in 1859. In the same year, she was one of thirty-eight female artists who petitioned the Royal Academy to allow women to attend their classes. In turn, she ran her own art classes in Exeter and wrote extensively on social subjects, such as the plight of seamstresses. Her most famous work was a painting on the subject, *The Seamstress*, with a young woman gazing out of the window praying for an hour's relief from her work to feel free from care, as in Thomas Hood's 1843 poem *The Song of the Shirt*.

Her paintings drew letters of admiration from other artists, including William Holman Hunt and most importantly for Anna, from Ruskin. Her correspondence with Ruskin started as an expression of her respect for the man and request for his opinion on art, but rapidly became filled with declarations of love which he not only did not reciprocate but obviously did not know how to handle. He pleaded with her to remain on subject, as in this missive of May 1861: 'There is no wonder you have not yet succeeded – you have been acting like a baby – or a mad-woman. You have power to succeed if you can only get the least particle of common-sense and discretion.' Finally, in 1862 she gave up her pursuit of him in order to actually

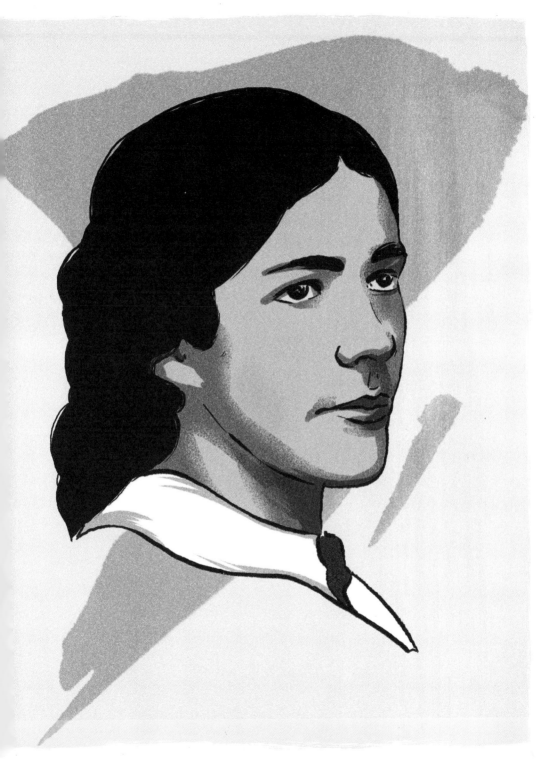

follow his advice and travel Europe to improve her art. Her paintings moved from modern subjects to landscapes, painted in vividly coloured detail from nature in the Pre-Raphaelite style.

Anna only returned to England when her sister Emily died in childbirth. Shortly afterwards, she married her widowed brother-in-law. Like Holman Hunt and Edith Waugh, they travelled to Europe to wed, as it was illegal to marry your in-laws in Britain at the time. Anna and her new husband, Francis Richard Martino, a steel mill owner, moved to Birmingham, where she exhibited her art at the Birmingham Society of Artists, continuing to use her maiden name professionally. She continued to exhibit right up to the year she died, a couple of weeks short of her eighty-sixth birthday.

Anna's reputation took a blow many years after her death when the main collections of her work fell victim to bombing in World War II. Without works of art in public collections, Anna Blunden was forgotten until recent research brought to light her contribution to art.

View on a North Italian Lake
Anna Blunden, 1898

Opposite – *The Seamstress*
Anna Blunden, 1854

ROSA BRETT
1829–1882

The oldest child and only girl among five siblings, Rosa Brett was conversely both daring and reserved when it came to her artistic career. Despite ill health, she forged her own path into Pre-Raphaelitism in the truest sense and never wavered from the original teachings of John Ruskin.

Rosa's father, army surgeon Captain Charles Curtis Brett, travelled with his work, and although Rosa was born in London and then travelled to Dublin, the family finally settled in Kent and remained there for life. Rosa and her younger brother, John, received art lessons privately from around 1841 and began to share a studio from 1850. Rosa's lifelong modesty came to the fore early when her brother took

their art to show to a possible patron and they chose Rosa's view of York, assuming it was John's, a mistake which he didn't correct and she didn't mention again. Other diary entries she kept at the time show how she would hide from visitors to the studio as all her work was being passed off as her brother's. She worked hard in the household, assisting her mother and helping to educate her younger brothers, as well as acting as studio assistant and secretary to her brother. All this she managed as well as her art, which was often sold as John's.

Rosa had no actual contact with the Pre-Raphaelite Brotherhood, although her brother was close friends with the Rossetti family.

The Hayloft
Rosa Brett, 1858

From Bluebell Hill
Rosa Brett, 1851

Rosa discovered Pre-Raphaelite ideals at source, through the writings of Ruskin, and this led her to paint outdoors, direct from nature. In 1852, Rosa became unwell, possibly with various spinal complaints that would plague her for her whole life, but still she worked outside in all weathers. She even travelled to Europe to continue working, and in 1858 she finally exhibited her work publically. *The Hayloft* (1858), a painting of a cat asleep in a meticulously studied hayloft, was exhibited under the pseudonym 'Rosarius', despite her brother's protests at hiding her identity behind that of a man's. Rosa obviously felt her status as a 'lady artist' would prove a hindrance.

She worked in watercolour and found landscape more successful than

Lake Geneva
Rosa Brett, 1855

Thistle
Rosa Brett, 1861

figures. Her detailed compositions resulted in newspaper reports praising her 'brilliance of colour' but wondering at the amount of time and effort she paid to, for example, a thistle. Unlike her brother who was able to travel and mix in society freely, Rosa's position as a respectable, middle-class, single woman meant she was restricted to her home in Kent. Possibly her isolation from the art world was why she remained true to Ruskin's teachings rather than moving into the second wave of Pre-Raphaelitism, led by Dante Gabriel Rossetti which focused more on subject rather than style. She exhibited a few times at the Royal Academy and at the Liverpool Academy of Arts and the Society of Lady Artists.

On the death of her parents, John and his family took Rosa into their home and she travelled to Wales with them, producing sketches of the landscape around Snowdonia.

Rather than finally being free to live the life of an artist, Rosa seems to have slipped into the same domestic, caring role for her nieces and nephews which only ended with her death from cancer in 1882, at the age of forty-two. Both hindered by self-effacement and her gender, there was no obituary for her in the newspaper, only her brother John's diary entry recording his sadness at her passing – 'and the grass grows over her in Caterham churchyard'.

CHRISTINA ROSSETTI

Being the youngest daughter in a family of fiercely intellectual academics did not seem to slow down Christina Rossetti. Her father was an exiled poet and Italian political writer, and her uncle was John Polidori, the writer of the first ever vampire-romance story, so it seems hardly surprising that Christina was drawn to literature as her passion. She blossomed precociously early, asking her mother to transcribe the stories Christina told her because she was too young to write. Other childhood activities, such as exploring the zoological gardens near her home in Regent's Park, seem to have fired her imagination. She started writing poems at the age of twelve and published them when she was seventeen. Despite writing about typically teenage obsessions such as love and death, her poems had a strong religious impulse, and some have even become popular carols, such as *In the Bleak Midwinter* (1872) and *Love Came Down at Christmas* (1885).

Life became harder for the Rossetti family when Christina's father became ill and the family lost its primary breadwinner. Christina assisted her mother in setting up a private school but secretly she feared being forced to follow her older sister into one of the nineteenth century's most loathed profession for decent girls: being a governess. The pressure and anxiety was so intense that Christina had a breakdown and spent a while in deep depression, lifted only by her dependence on Christianity, which she felt saved her life.

The Girlhood of Mary Virgin
Dante Gabriel Rossetti, 1849

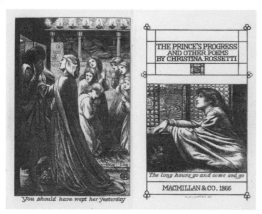

The Prince's Progress and Other Poems
by Christina Rossetti
Binding and illustrations by Dante Gabriel Rossetti, 1866

She became engaged to the Pre-Raphaelite painter James Collinson, but after he converted to Catholicism, Christina felt she could no longer marry him. She also refused the proposal of noted linguist Charles Cayley and painter John Brett. Brett's persistence is rumoured to have been the inspiration of a scathing poem about how a woman tries to reject a suitor whose male privilege makes him unable to understand how she could refuse, 'No, Thank You, John' (around 1857).

When Christina came to publish her collection of poems, she turned to her brother Dante Gabriel Rossetti to provide illustrations. The closeness between the siblings was not without Christina's shrewd awareness of her brother's world. She wrote a poem entitled *In an Artist's Studio* (1856)

about the disparity between the glamour of a woman in a painting and the life of a model, waiting around, posing and never truly being seen as herself. Possibly her own brief stint as her brother's model put Christina off doing it again, her face gracing his earliest Pre-Raphaelite paintings of the Virgin Mary, which must have suited her religious leanings at least.

Christina's spirituality expressed itself through charity, and she worked in a refuge for 'fallen' women, as well offering her support to political causes such as the abolition of slavery, animal cruelty and working to prevent young girls from being sold into sexual exploitation on the streets. She tried to abstain from activities she enjoyed as a mark of her Christianity, so she gave up playing

Christina Rossetti (unfinished)
John Brett, 1857

chess because winning gave her too much pleasure. Her piety was such that she was given the honour of a feast day, 27 April, in the Anglican Church.

Christina was a private person, living for her writing and charity, keeping only a small circle of friends outside her family, including Lewis Carroll and Ford Madox Brown. In later life she developed Graves Disease, an affliction of the thyroid, one of the symptoms of which is bulging eyes, which can be seen in some of her brother's later sketches of her. She died of breast cancer aged sixty-four, but unlike her brother's art which fell out of favour, her poetry continued to gain popularity into the twentieth century. With its complex themes of sexual repression, love and loss, her poetry is considered to be a strong influence on writers such as Virginia Woolf and Philip Larkin. *Goblin Market* continues to intrigue readers today with its dark, sensual undertones and it even featured in a photospread in *Playboy*. I'm not sure Christina would have wholly approved of that....

Ecce Ancilla Domini
Dante Gabriel Rossetti, 1849-50

RUTH HERBERT
1831–1921

Very few of the women in this book could truly claim to have been a Pre-Raphaelite icon within their own lifetime. One who can is the actress Ruth Herbert, who made the role of 'Lady Audley', the mad, Burne-Jones-style murderous anti-heroine of *Lady Audley's Secret* her own. She also managed a theatre, gave Sir Henry Irving his big break in show business and wrote a cookbook. Not bad for the daughter of a Bristolian brass founder….

Louisa Ruth Herbert was born in Clifton, Bristol in 1831, but as a child moved with her mother to London after her father's death. Being tall and agile, with bright blonde hair, she easily found work on the stage, dropping the 'Louisa' in favour of plain 'Ruth Herbert'. One early reviewer remarked 'she was not a remarkable actress but her appearance was wonderful indeed', which is charmingly backhanded. The same year as she debuted in London, aged sixteen, she married a libidinous stockbroker named Edward Crabbe (sometimes spelt 'Crabb'), who seduced the parlour maid while his wife was off building her reputation as a comedic actress in the West End. Dispensing with the erstwhile Mr Crabbe, she married again to John Rochfort, an Irish amateur artist with pretentions to French nobility. By 1856 she was a celebrity, being invited to the best gatherings, a regular at Little Holland House, the home of the influential Prinsep family. She was

Portrait of Louisa Ruth Herbert
Dante Gabriel Rossetti, 1858

noticed for her Pre-Raphaelite appeal early on, as the *Illustrated Times* wrote 'Ah! If I were Millais I would paint her in my next picture in her pure white silk dress, if I were Munro I could carve a lovely medallion from her profile.'

Possibly with an eye to extending her reputation as a professional beauty, Ruth agreed to pose for Dante Gabriel Rossetti and soon was much in demand from other artists such as Valentine Prinsep and George Frederic Watts.

It took Rossetti a little time to secure her services as a model and very overexcited he was too. He wrote to William Bell Scott in 1858, 'I am in the stunning position this morning of expecting the actual visit at ½ past 11 of a model whom I have been longing to paint for years – Miss Herbert of the Olympic Theatre – who has the most varied and highest expression I ever saw in a woman's face, besides abundant beauty, golden hair, etc. Did you ever see her? O my eye! she has sat to me now and will sit to me for Mary Magdalene in the picture I am beginning. Such luck!'

All that Pre-Raphaelite nonsense was merely a sideshow to Miss Herbert's desire to manage her own theatre. She assumed the management of the St James Theatre where she took on a young Henry Irving as her assistant and leading man, giving a break to the actor who would define nineteenth-

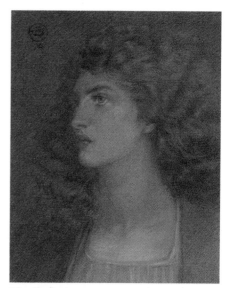

Miss Herbert
Dante Gabriel Rossetti, 1876

century Shakespearean performance. However, for Miss Herbert her days on stage were drawing to a close and she retired with Rochfort to travel on their schooner, *Leda*. She occasionally appeared on stage but her last project was a book of recipes and household management, *The St James Cookbook*, named after her theatre, published in 1894. Ruth lived out the remainder of her life in Steyning – coincidentally the birthplace of fellow stunner Fanny Cornforth – living alone with her servants after the death of her second husband in Paris, until she died in April 1921. Whilst not hitting the performance heights of Ellen Terry, her portraits and awareness of her brand – the Pre-Raphaelite heroine – meant that she gained immortality.

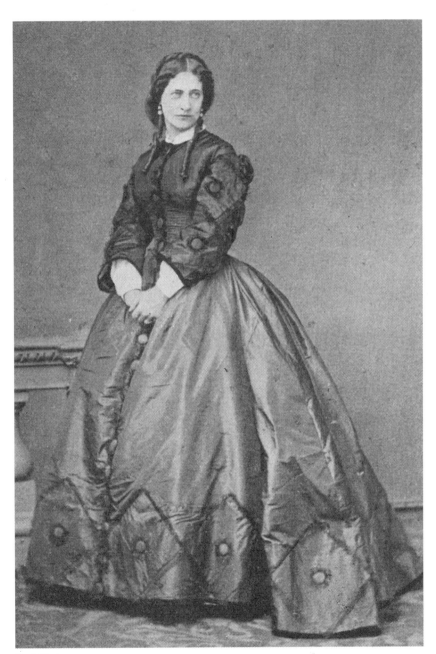

Ruth Herbert
Unknown, n.d.

Joanna Boyce

1831-1861

Being the sister of an artist in a rather wealthy family, Joanna Boyce's progress in her own artistic career should have been reasonably straightforward but it was besieged by obstacles. She followed her brother George Price Boyce to art school but when he fell ill, Joanna was expected to give up her studies in order to nurse him. After he recovered and the pair returned to school, Joanna's studies were once more halted by the death of her father, who had been the main force behind encouraging her artistic career, but finally, at the age of twenty-three, she started at the Government School of Design and began exhibiting at the Royal Academy.

Joanna's first painting was a rebel Anglo-Saxon princess, *Elgiva* (1885), who came a cropper when she got on the wrong side of Bishop Odo,

and the painting was received very enthusiastically. It was bought by her brother George and it remains in the family today. George was busy getting to know the Pre-Raphaelite Brotherhood and the diary he kept of this period gives us insights into

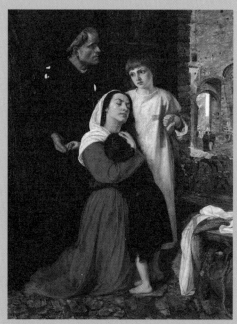

The Departure: An Episode of the Child's Crusade 13th Century
Joanna Boyce, 1857-1861

Gretchen
Joanna Boyce, 1861

fellow artist Henry Tanworth Wells, who asked her to marry him, but she refused at first, stating that marriage was a form of slavery that reduced women as wives and mothers to narrow lives. Valuing her independence, she wanted to remain free to be an artist, which she didn't think she would be as a married woman with an inevitable house full of children. Henry kept asking and after a few years Joanna finally consented. The couple toured Italy, then settled back in England where, as Joanna had ruefully predicted, the babies followed.

Despite her fears over the conflation of the lives of mother and artist, Joanna managed to combine the two. Her subject manner reflected her new role of mother and she featured her children in many of her popular canvases. Her style reflected the Pre-Raphaelites, and her brother was close friends with Dante Gabriel Rossetti, who described Joanna as 'a wonderfully gifted woman'. She also sought out Fanny Eaton to be her model, portraying her as a proud and beautiful woman. Rather

the lives of the men and women he met. Especially the women, as George had an eye of the ladies. Meanwhile, Joanna's success was so great that she was encouraged to travel to Paris and write reviews on exhibitions there. She met

Portrait of Sidney Wells
Joanna Boyce, 1859

than slowing her pace of work, her children seem to have provided more inspiration. Even while pregnant with her third child, Joanna worked throughout, keeping a project book listing at least thirty further paintings she had planned after the birth. This work was sadly not to be as Joanna died of complications after the birth of her child, aged only thirty. In one of her obituaries it said 'In her, English art has lost more than it knows.'

Emma Watkins
1832-1914

On a cold November afternoon in 1850, Emma Watkins was walking back across a frozen field after a long day of work when a young artist, William Holman Hunt, approached her. He and John Everett Millais were in Surrey painting landscape for their new works; Millais had been painting Hogsmead River, near Ewell, for *Ophelia* (1852) and Hunt had been painting fields and sheep for *The Hireling Shepherd* (1851), a piece about temptation and the self-absorption of clergy while their flock went astray.

Hunt offered Emma money to come to London and pose for him as the saucy shepherdess. The Watkins family was very poor, reliant on Emma's brother selling groundsell on the streets, and so the chance of earning quite a lot of money for just sitting still was too good to be true.

Emma travelled to London, taking her fiancée, a sailor, with her to keep her safe, and sat in the warm studio while Hunt drew her. On the third visit she decided to leave her fiancée back in the countryside

and she stayed in London while the painting was progressed. Artist and model were left alone, unchaperoned, and people began to talk. It seems likely that they had an affair, as years later new wife Edith Holman Hunt destroyed all Hunt's letters mentioning Emma.

Emma was very popular with Hunt's friends who thought she was pretty and called her the 'Coptic', referring to the mysterious Egyptian sphinx. They teased Hunt about his attachment to Emma, joking that Emma's fiancée would be jealous and even ran up and down Hunt's stairs, hammering on his door, pretending to be Emma's young man as a prank.

The painting was finished and Emma was sent home to her fiancée whom she married but whatever it was that had occurred during the creation of the piece was not about to be forgotten. In Charles Dickens's magazine *Household Words*, a short story by Robert Brough entitled *Calmuck* told the tale of a painter who had discovered a beautiful country girl, nicknamed 'Calmuck',

and brought her to London where the couple had an affair behind the back of the girl's fiancée, a sailor. There was even the detail that the painter's friends would storm up and down the stairs to scare him.

Hunt was livid and threatened to sue Dickens. Hunt had built up his reputation as a moral and deeply religious painter, which could easily have been destroyed by such juicy and probably true gossip. It also threatened his new relationship with Annie Miller, who might have been smart enough to see the hypocrisy in Hunt's attitude to her, especially at the end of their relationship. No one seems to have given much thought to Emma and her reputation, but possibly in the middle of the Surrey countryside, the snide bickering of the artistic elite doesn't really mean very much.

Hunt went on to great success and the story didn't affect him in the long run but we don't know if the same was true for Emma. She was married to her sailor, with children, but her health suffered and she was committed to an asylum aged only forty years old, where she would live for the next forty years, dying in 1914. Although she died in obscurity, alone in an asylum, she remains one of the most familiar figures in Pre-Raphaelite art due to a chance meeting in a muddy field.

The Hireling Shepherd
William Holman Hunt, 1851

FANNY & EDITH
HOLMAN HUNT
1833 - 1866 & 1846 - 1931

Daughters of Dr George Waugh, chemist to Queen Victoria, Fanny and Edith shared the love of the same man, although mercifully not at the same time. Their sister Alice married the Pre-Raphaelite sculptor Thomas Woolner in 1864, shortly followed by Fanny, who married fellow Pre-Raphaelite Brotherhood member William Holman Hunt the year after. Despite Hunt's comparative poverty, the family welcomed the up-and-coming artist. Teenage Edith was bridesmaid at her sister's wedding and William Michael Rossetti was the best man. Finally settled down after a few scandalous affairs, Hunt set about painting Fanny's features over the scraped faces of Annie Miller in paintings such as *The Awakening Conscience* (1853) and *Dolce Far Niente* (1866). The family must have been delighted when the couple announced that Fanny was expecting their first child in 1866, but possibly less thrilled when Hunt added that the couple would be travelling to the Holy

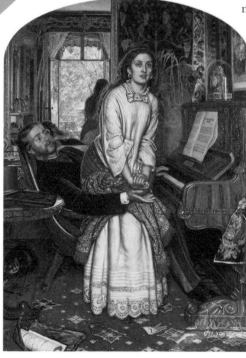

The Awakening Conscience
William Holman Hunt, 1853

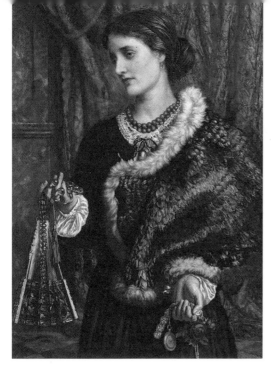

The Birthday (A Portrait of the Artist's Wife Edith)
William Holman Hunt, 1868

ill and exhausted, so when the time came to give birth to their son, she was tired and suffering from a fever. She died shortly after, leaving William Holman Hunt alone with their baby son, Cyril Benoni, a biblical name which meant 'son of my sorrow'.

Hunt continued to work abroad, but the lifestyle of an artist, especially one travelling, did not lend itself to raising children. Cyril went back to the broken-hearted Waughs, and Edith made a point of caring for her lost sister's son. Hunt returned and visited often, slowly falling in love with his sister-in-law. For her twenty-first birthday in 1868, Hunt painted a portrait of her wearing a cameo brooch that he had given Fanny.

Land so he could continue with his religious art. Dr Waugh was adamant that no good would come of his daughter travelling whilst pregnant and dramatically declared that he doubted he would see her again.

The couple set out for Egypt but the plague was raging in Europe and so they ended up stalled in Florence. The heat was stifling and Fanny was by then heavily pregnant, but William was so in love with his wife that he only wanted her to model for his new painting of *Isabella and the Pot of Basil* (1868), a beautiful woman grieving for a lost love. Fanny had to stand for hours at a time, making her

Back then, it was against the law for a widowed man to marry his wife's sister, so the couple decided if they were to be married they had to travel abroad. This scandalised the family and Woolner and Alice refused to speak to the couple again, but Hunt and Edith wanted to spend their life together, so married in Switzerland in 1873. The loss of friends through their relationship led Edith and Hunt to campaign to change the law against marriages between in-laws and in 1907 the Deceased Wife's Sister Act made it legal for a marriage such as theirs to take place in Britain.

Opposite – *Isabella and the Pot of Basil*
William Holman Hunt, 1868

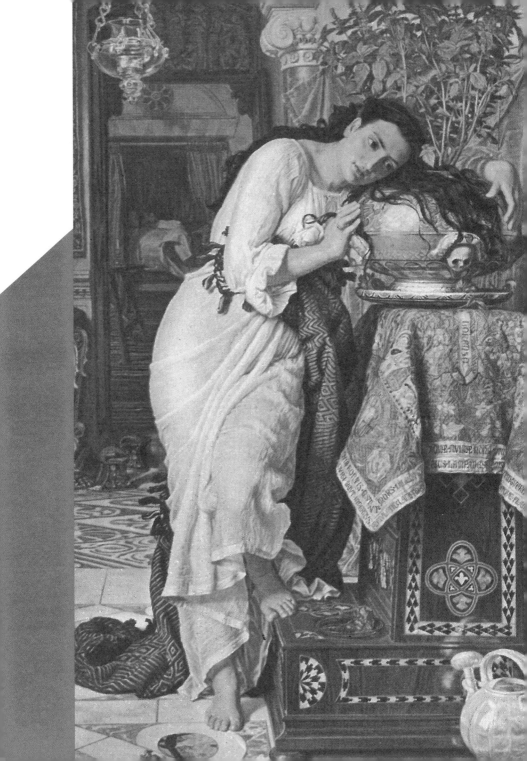

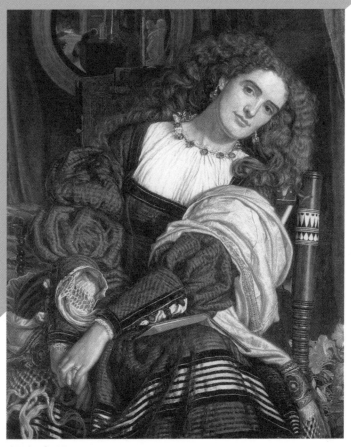

Il Dolce far Niente
William Holman Hunt, 1866

While Hunt painted, Edith wrote books about their travels, publishing a book entitled *The Children at Jerusalem* in 1881. When William died, Edith kept their home as a shrine to him, labelling her teacups with the names of famous people who had drunk from them, and a little jealous that after all that time, her sister got to be reunited with William in heaven, while Edith remained alive, telling stories about life with the famous artist to her granddaughter, Diana, who would go on to write two biographies about her grandparents and their love. Edith died in 1931, aged eighty-five, after a particularly grisly accident with a motor van in Kensington High Street.

Opposite – *Fanny Waugh Hunt*
William Holman Hunt, 1866-8

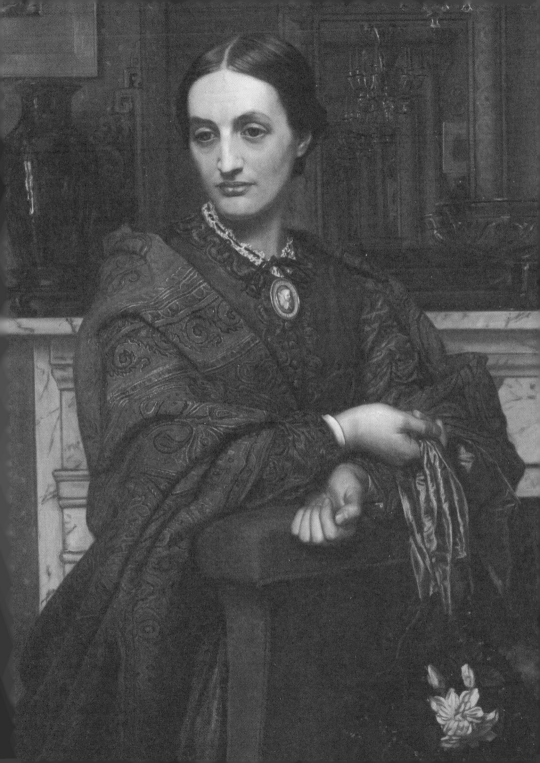

Aglaia Ionides

1834-1906

Unlike her cousins Maria Zambaco and Marie Spartali Stillman, Aglaia Ionides didn't feel the need to display the art works she created. Like the other two, Aglaia was from a rich and influential Greek family at the heart of the cultural and artistic life of London. Her father, Alexander Constantine Ionides, was a textile and wheat trader whose large house in Holland Park became a social hub for Pre-Raphaelite and Aesthetic artists. It was there that the beautiful and talented Aglaia met the men with whom she wanted to work in partnership to create their artistic visions.

Starting as a model for artists such as Dante Gabriel Rossetti and Edward Burne-Jones, Aglaia specialised in designing costumes for the artists. She drew them, sourced the fabric, hand-sewed them and then styled the models in the way she wanted. She made at least a dozen different costumes for Burne-Jones's enormous painting *The Golden Stairs* (1880)

which featured many of the young women of her social circle such as May Morris, as well as Lady Lovelace and Mary Gladstone, daughter of the prime minister.

George du Maurier, in his novel *Trilby* (1894), described a character based on Aglaia as 'so beautiful and stately and magnificently attired'. She was also known for her intellect and enjoyment of lively debate, which others found 'eccentric' in a woman. Her nephew, Alec Ionides, remembered her as 'the conversational star of this circle' and she often had to act as hostess at her father's society parties in the place of her mother, whose English was not quite fluent enough.

After marriage to Theodore Coronio, a handsome Greek businessman, the couple moved into an adjoining house to her family and Aglaia amassed a sizable art collection of her own. Anna Alma-Tadema, daughter of Lawrence Alma-Tadema, painted a corner of

Portrait of Aglaia Coronio
George Frederic Watts, 1874

their drawing room which displayed Aglaia's many objects d'art and a large Rossetti portrait of Jane Morris. Aglaia and Theodore had two children, but the marriage was not a happy one. Aglaia sought deep relationships of friendship and affection with her Pre-Raphaelite colleagues, especially William Morris, with whom she could discuss art and literature, and he encouraged her in her creative endeavours, including bookbinding.

The marriage ended when Coronio left Aglaia due to his alleged financial difficulties, even though she always had plenty of money. After a particularly large dinner at his club in 1903, he suffered a massive heart attack in the newly opened Tube somewhere between Shepherd's Bush and Marble Arch, leaving his widow a mere £93.

Aglaia nursed her beloved daughter Calliope through her final illness in 1906, and the day after Calliope died, Aglaia stabbed herself repeatedly with a pair of scissors and a silver-handled penknife. As she lay dying, her horrified friends asked her what she had done. She replied 'It is my broken heart.'

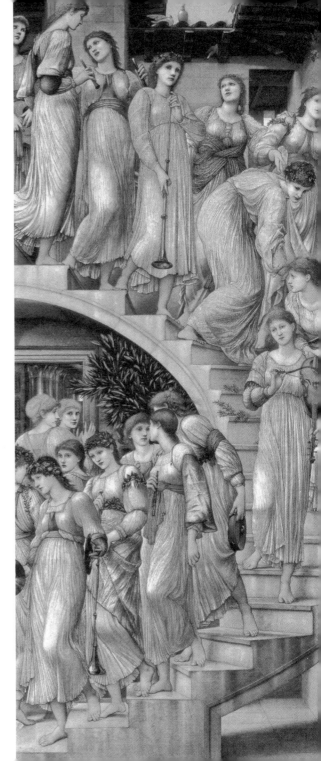

The Golden Stairs
Edward Burne-Jones, 1876-1880

ANNIE MILLER
1835–1925

Annie Miller's start in life was not promising. Her mother died shortly after little Annie popped into the world, and her father, Henry, a veteran of the Napoleonic Wars, was no match for his two little daughters. He left Annie and her sister Harriet in the care of his brother George Miller, and Bess, his wife, who lived behind a pub in Chelsea. When Annie was old enough to pull a pint, she went to work for the Cross Keys public house in Lawrence Street, which was run by a Mrs Hill, who was not only the landlady but also a suspected prostitute, which hints at superior time management skills or a touch of Victorian prejudice. By contemporary accounts, Annie and Harriet were dirty, lice-ridden and almost feral, so it is little wonder that she caught the eye of William Holman Hunt, the Pre-Raphaelite painter.

Hunt's attraction to Annie is slightly more understandable if you consider he was looking to create a painting of a fallen woman, and so Annie's forward manner and grubby beauty might have been exactly what he was looking for. Also, it was a common

fixation among his brother-painters to want to 'save' women and perform Pygmalion-like transformations of no doubt appropriately appreciative young women who were secretly beautiful behind the smell of horse

Portrait of Annie Miller
Dante Gabriel Rosetti, 1860

dung. Hunt took Annie out of her humble surroundings, rented her decent accommodation with access to a bathtub and arranged for her to have lessons in how to be a lady. If she accomplished this, Hunt promised he would marry her. He painted Annie as the kept woman, rising from the lap of her illicit lover in *The Awakening Conscience* (1853), and

an idle woman of wealth in *Il Dolce Far Niente* (1866). However, the ever so religious Hunt was struck by the need to paint truthful biblical scenes, so packed his bag for the Holy Land, promising to return in a few months. Annie was left to attend her lessons, live quietly and pose only for the artists Hunt felt were appropriate. She posed for John Everett Millais and George Price Boyce, but under no circumstances was she allowed to pose for Dante Gabriel Rossetti.

I think the first rule of infidelity is that if you are cheating with another artist, make sure he doesn't produce large oil paintings that give the game away. Hunt returned from painting Jesus and unhappy goats to find not only had Annie met up with Rossetti but he had painted her in *Dante's Dream at the Time of the Death of Beatrice* (1856). Hunt was fuming and felt he had been made a laughing stock by his so-called friends, and attempted to have Annie sent to Australia so he would never have to see her again. Annie sensibly refused to be sent packing, so instead Hunt scrapped her face out of every likeness he had made of her. Rossetti offered her some modelling work, but Annie found herself back in her lice-ridden home. However she had made important friends during her time with the Pre-Raphaelites, probably whilst she was meant to have been learning to

walk with a book on her head and behave properly. One of these friends was Captain Thomas Thomson, a cousin of the ever so naughty Lord Ranelagh. Captain Thomson married her and they moved away from the artistic melee of London to the south coast where they lived out a long and happy life with their children.

Woman in Yellow
Dante Gabriel Rossetti, 1863

Annie died at the respectable age of ninety, and despite Hunt's attempt to obliterate her face from Pre-Raphaelite art, she still regards us coolly from *Helen of Troy* (1863) by Rossetti, an image of a woman whose beauty caused so much trouble.

Opposite – *Portrait of Annie Miller*
Dante Gabriel Rossetti, 1860

Fanny Cornforth
1835-1909

Of all the models and muses of the Pre-Raphaelite circle, Fanny Cornforth found herself the target of the most outrage and notoriety not only in her lifetime but after it, and all because she refused to be quiet. The daughter of a blacksmith, in the village of Steyning where every other person seemed to be a blacksmith, she was born plain 'Sarah Cox'. There just were not enough horses to justify that many smithies and poverty proved fatal to most of her family, including her mother and her little sister Fanny (whose name she adopted). In a last-ditch attempt at some fun in life she travelled to London to see the firework display for the return of Florence Nightingale from the Crimea.

Whilst walking through the pleasure garden watching the celebrations, Dante Gabriel Rossetti ran up behind the beautiful young woman and pulled all the pins out of her hair. Fanny turned, outraged, but the artist explained she was the most beautiful woman he had ever seen and he needed her to model for him, which delighted her. The next day she visited his studio and remained Rossetti's close friend, lover, confidante and nurse for the next twenty-five years.

Unlike other models and mistresses of the Pre-Raphaelite circle, Rossetti never attempted to 'gentrify' Fanny. He liked her accent, often described as 'cockney' which then was just a term for working class, and he liked her earthiness, practicality, robust health (in contrast to Elizabeth Siddal's constant ill-health) and passion. Many of his friends and family, however, did not feel the same way. The poet and painter William Bell Scott made up a story about how Rossetti had met Fanny whilst she was spitting nutshells at men in the street, and called her 'the creature with three waists', alluding to her figure. Rossetti nicknamed her 'Elephant', apparently in regard to her weight, but also referred to himself as 'Rhino' for the same reason. They must have been delighted when Rossetti stopped using Fanny as his model in 1865, replacing her with Alexa Wilding,

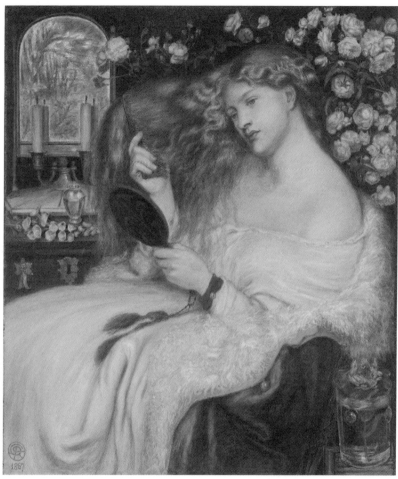

Lady Lilith
Dante Gabriel Rossetti, 1867

but she wasn't about to leave the man she loved.

Even though Fanny had married another man, Timothy Hughes (also known as Timothy Cornforth) as a panicked response to Rossetti

marrying Elizabeth Siddal, she saw very little of her husband in the decade they were married. Fanny lived just around the corner from Rossetti, and even when he no longer used her as a model she was frequently at his home keeping him

company and contacting the spirit of poor departed Elizabeth through séances. Rossetti's family attempted to free him from the attractions of the warm, kind-hearted Fanny and he often abandoned her for weeks and months at a time. When he left Fanny to live with his mother and sister, he told her to make her own life without him. When he returned home shortly afterwards, after finding life with his female relatives to be appallingly dull, he was outraged to find Fanny had found herself a pub to run and a gentleman to help her. She came back to him the moment he called but left him in no doubt that she was capable of looking after herself.

Fanny was desperately hurt when Rossetti spent a couple of summers at Kelmscott Manor with Jane Morris. Despite many of Rossetti's friends and the model Alexa Wilding being invited to stay, Fanny was firmly told she was not allowed anywhere near. Alexa returned from her visit and told Fanny of the romantic shenanigans in the Oxfordshire love nest, resulting

Sidonia von Bork
Edward Burne-Jones, 1860

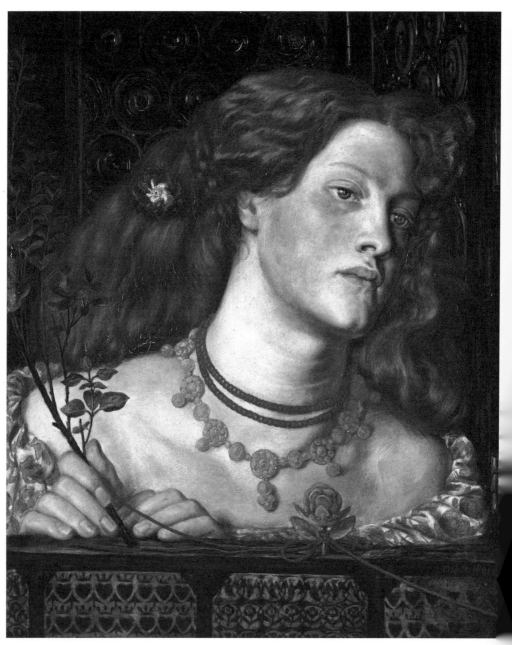

Fair Rosamund
Dante Gabriel Rossetti, 1861

in many anguished letters from Fanny to her erstwhile lover. Still she forgave him and was one of the few people he asked for when his drug addiction caused frequent breakdowns in his health.

The family finally removed Rossetti to Birchington-on-Sea when his health declined. The first that Fanny knew of his death was when she read about it in the newspaper, and his brother, William Michael, delayed his reply to her pleas to attend the funeral until after the event so she could not attend. There started a removal of Fanny from Rossetti's reputation and her name was not mentioned in subsequent biographies, the paintings she modelled for often attributed to another sitter. Her response was to hire a gallery just down the road from the Royal Academy where the family was holding the official retrospective exhibition and hold her own exhibition of Rossetti's art. When American art collector, Samuel Bancroft Jr, sought out Pre-Raphaelite paintings and stories, he found Fanny and for the first time in

Fanny Cornforth
Dante Gabriel Rossetti and William Downey, 1863

her life someone listened to her life story without prejudice. The works she sold him and the letters they exchanged now form part of the Delaware Art Museum's collection of Pre-Raphaelite art.

Dedicating her life to Rossetti had meant sacrificing her own chance of a family and when she grew old, she had no one to care for her. Deaf and difficult, Fanny was taken to Graylingwell Asylum in West Sussex where she died, aged seventy-four.

Fanny Eaton

1835-1924

Fanny Eaton was born into slavery in St Andrew, Jamaica, in 1835. Her mother, Matilda, was a slave and there was suspicion that her father could well have been their owner. However, the 1837 abolition of slavery freed Fanny and her mother, who travelled to London. Their life was not much easier in Britain; Fanny worked hard as a domestic servant in her early teens, but at least the little money they earned was theirs. Aged twenty-two, Fanny married a cabbie, James Eaton, and they had ten children, which proved to be expensive. In order to support the family and supplement James's income, Fanny became an artist's model.

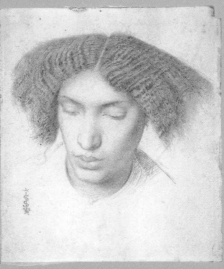

Although women from all over the Empire lived in Victorian London, not many decided to corner the market on canvas. The Pre-Raphaelite artists found Fanny's unusual beauty exactly what they needed. She caught the imagination of Simeon Solomon, whose painting of her was exhibited in the Royal Academy. This in turn attracted the attention of other artists who wanted to know who this beautiful, exotic woman was. She posed for

Portrait of Fanny Eaton
Simeon Solomon, c.1860

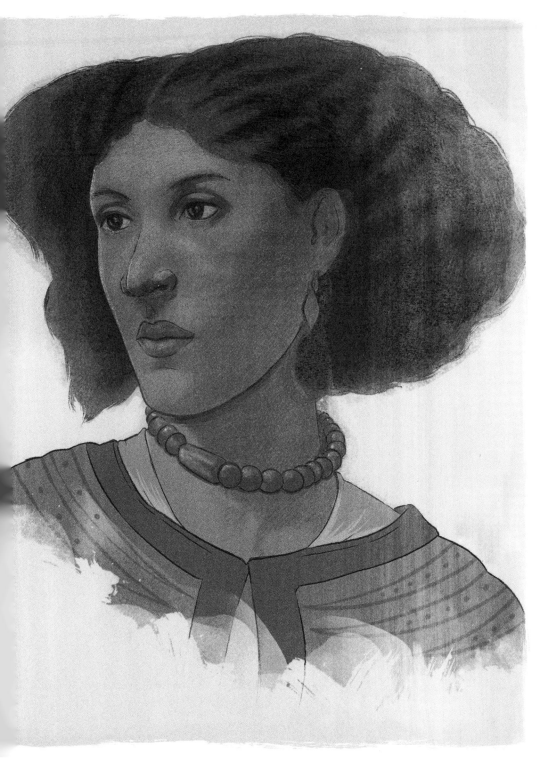

Simeon's sister Rebecca, and for Joanna Boyce Wells, who painted a famous portrait of her, rumoured to have been a study for the portrait of a Syrian Warrior Queen. Fanny was also a bridesmaid at the back of Dante Gabriel Rossetti's painting *The Beloved* (1865–6) and Rossetti described Fanny as an incomparable beauty with a very fine head. He employed Fanny because her soulful eyes and mass of crisp hair reminded him of Jane Morris, the woman he felt was one of the most beautiful in the world. In early drafts of the painting he included a black servant girl who might well have been one of Fanny's children, as some of Fanny's daughters also helped the family finances with modelling. Among her other employers at this time were Albert Moore, Frederick Sandys and John Everett Millais, all of whom used her in biblical scenes or as a sorceress. In their work she not only portrayed women of her own Afro-Caribbean decent but also a range of racially ambiguous figures from the Holy Lands, Europe and all points between. In contrast to the contemporary habit of showing people of colour as being somehow lesser than the white artists portraying them, the Pre-Raphaelite artists portrayed Fanny almost without exception as caring, dignified and beautiful.

Jephthah
John Everett Millais, 1867

Head of a Mulatto Woman (Mrs. Eator
Joanna Boyce Wells, 1861

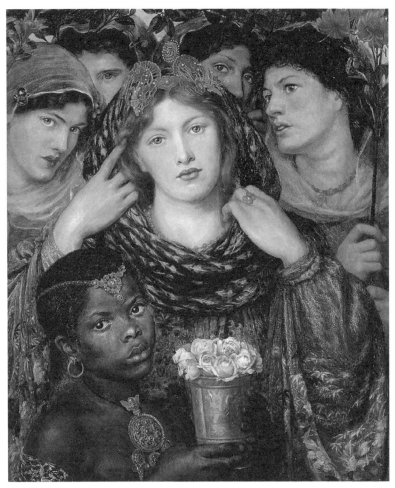

The Beloved
Dante Gabriel Rossetti, 1865

When James died in 1881, and with her children grown-up and married, Fanny returned to domestic service as a cook for a family on the Isle of Wight, but in old age she turned to her children, all of whom had married well and lived comfortably. Her sons fought in World War I and her daughter Julia, who had married carpenter Thomas Powell, welcomed her mother into her home for the last years of her life. She died, aged eighty-eight, in the comfort of her daughter's home, far from her beginnings as a slave in Jamaica.

Jane Morris
1839-1914

Jane Burden was not at all what the Victorians considered beautiful. She was tall, awkward, with a halo of frizzy hair and olive skin. Her father worked in Symonds's Livery Stables in Oxford and Jane was no doubt destined for a life sewing, like many of the other Pre-Raphaelite models, until one fateful night she was spotted in the theatre by two over-excited artists. The artists were Dante Gabriel Rossetti and Edward Burne-Jones, and they were in Oxford painting a mural at the university (1857–9). They were looking for a model for Queen Guinevere in their painting of King Arthur, and Jane had just the right look. Rossetti, on a break from Elizabeth Siddal (whether Miss Siddal was aware of this or not) took no time in romancing Jane, who must have been delighted to be appreciated for the first time, especially as it was by someone who didn't smell like horses. However, as was often the way with Rossetti, he was summoned back to his beloved, dumping Jane back in the gutter. Jane must have been broken-hearted but, luckily for her, Rossetti wasn't

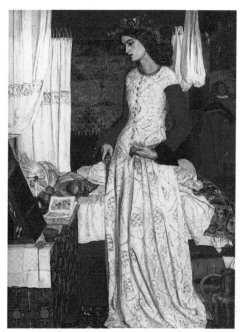

La Belle Iseult
William Morris, 1858

the only one who had fallen for her. One of the Pre-Raphaelite followers, an earnest young man called William Morris, began his very quiet courtship of his mentor's discarded model. He painted her as *La Belle Iseult* (1858) in her bedchamber but was not satisfied with his awkward efforts. On the back of the canvas he

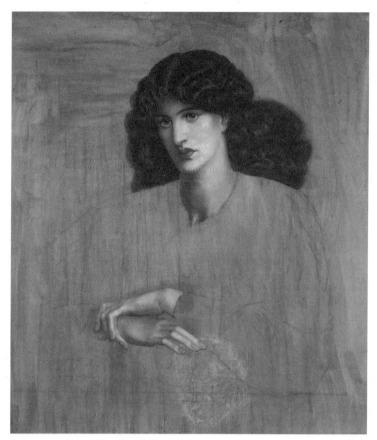

La Donna della Finestra
Dante Gabriel Rossetti, 1881

wrote 'I cannot paint you but I love you.' He was rather well off and she would never have to worry about the smell of horses or working for a living ever again. Jane married him.

As part of her engagement to William, Jane attended lessons to become a lady. She learnt French and Italian, how to play the piano and perfected her skills in needlework, all of which she did impeccably. She learnt to talk and walk so gracefully that she was referred to as 'Queenly'. Unlike Annie Miller, Jane applied herself to her transformation and in no biographical piece after her marriage did anyone allude to her humble beginnings. The only person to hint at it was George Bernard

Shaw, who allegedly created his play *Pygmalion* (first performed in 1913), the basis of the musical *My Fair Lady*, on Jane's makeover from grubby working girl to graceful society hostess.

Morris might have suspected he was Jane's second choice, but he seemed to strive to make her life as luxurious as possible. He commissioned a new house for them, the Red House in Bexleyheath, which soon became home to their growing family with the arrival of daughters May and Jenny. However, the dissatisfaction that had lain latent between Jane and her second-choice-husband grew after the death of Elizabeth Siddal and Rossetti's slow insinuation back into Jane's life. Rossetti chose her as his muse, which became an obsession, and Morris, attempting to shield his family from scandal, rented a manor house in the Oxfordshire countryside, Kelmscott Manor, for Rossetti and Jane. Morris very wisely took himself off to Iceland on a sturdy little horse to think about Vikings.

Rossetti's dependence on drugs ended the affair between them, as Jane did not want his influence to affect her daughters. Although May grew to be a designer and writer in the image of her father,

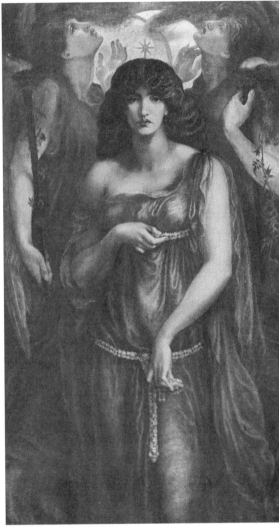

Astarte Syriaca
Dante Gabriel Rossetti, 1876-7

Jenny's health was badly affected by an illness that resulted in epileptic seizures. Neither Morris nor Jane wished their daughter to be locked

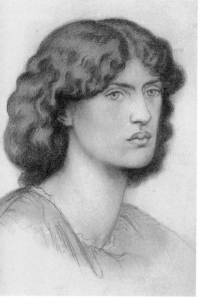

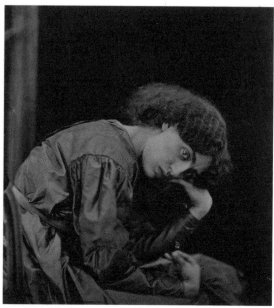

Jane Morris
Dante Gabriel Rossetti, 1869-70

Jane Morris
John Robert Parsons, 1865

away in a hospital, which at that time was one suggested solution for Jenny's care, so Jenny remained at Kelmscott with her family. Jane found a second love in her life, the political activist, writer and all-round lothario Wilfrid Scawen Blunt, who wrote that his affair with Jane made him feel closer to his hero Rossetti. In their own way, both Blunt and Morris encouraged Jane to get involved in politics, supporting Home Rule in Ireland and sending money in support of two starving needleworkers accused of theft, writing in their support to the newspapers.

After Morris's death, Jane retired to Kelmscott Manor with her daughters. She was fêted one last time in Pre-Raphaelite art by Evelyn de Morgan, who pictured her as an ageing beauty watching mournfully as the sands of time stream through an hourglass. Her last act before she died was to buy Kelmscott Manor for her daughters to live in for the rest of their lives. Today it is a museum of the Morris family's life and a tribute to the enormous love Jane, a reserved stable-hand's daughter from the back streets of Oxford, inspired in others.

Opposite – *Jane Morris*
John Robert Parsons, 1865

KATE PERUGINI

1839–1929

Known to the world as Charles Dickens's daughter, Kate was the youngest surviving child of ten, and acknowledged among her siblings as her father's favourite. Father and daughter were very similar in temperament, quick to anger, leading to her nickname of 'Lucifer Box'. The family travelled widely in Europe when she was a child, and her father not only wrote his novels but delighted in arranging amateur dramatics to which he invited audiences. At a play in 1857 entitled *The Frozen Deep*, by her father's friend and fellow novelist Wilkie Collins, Queen Victoria was in the audience as Kate acted on the stage.

Kate showed a talent for art while young and was enrolled at Bedford College when only twelve years old, the first college in England to provide university level education to women. It was through Willkie Collins that Kate met her first husband, Collins's brother and Pre-Raphaelite painter Charles Allston Collins. Charles had been madly in love with Maria Rossetti but she had turned him down in favour

Kate Perugini
John Everett Millais, 1880

of becoming a nun. With Kate he found better luck and the two were close friends before their marriage. However that's as far as it went for medical reasons and the marriage remained platonic, as Charles became semi-invalid early in their married life. Kate cared for him and had discrete romances, possibly with Val

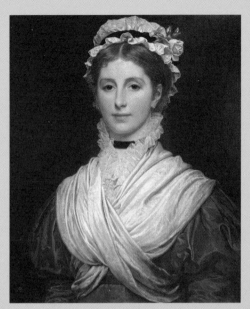

Kate Perugini
Charles Edward Perugini, n.d.

Black Brunswicker (1860) and after her marriage Millais produced a portrait of Kate (1880), which was among his best work. It was certainly a less odd experience than posing as the desperate lover of the Black Brunswicker soldier about to be killed in the war. In the painting, Kate clings to him, trying to prevent him from leaving, but in reality neither Kate nor the soldier met, both posing at separate times using a wooden post as the stand-in for the missing figure.

The couple's life was not without sadness. Their son died at less than seven months old, but their love for each other carried them through. Perugini used his wife as the model for many of his beautiful canvases. Kate worked hard on her art, exhibiting regularly at the Royal Academy, the Society of Watercolour Painters and the Society of Lady Artists (later renamed the Society of Women Artists). She spoke at length on her father's works, always positively despite the differences they had had in their relationship after his infidelity and subsequent treatment against her mother. She died aged ninety of exhaustion, after a life tirelessly spent in search of inspiration. One of the newspaper reports of her death stated that even in old age she retained 'the charm and brilliance which made her well known as a gifted speaker and an artist in London....'

Prinsep. Collins died in 1873 and barely six months later Kate secretly married another painter, Italian-born Charles Perugini.

After her marriage to Perugini, Kate's artistic career flourished. She worked on some collaborations with her husband and built a reputation for herself as a successful portraitist as well as a writer. She was the only one of Dickens's children to follow him into the arts. She started exhibiting with the Royal Academy in 1877 and the couple boasted a wide circle of influential friends in the art world. Kate had modelled for her father's friend John Everett Millais in *The*

Opposite – *The Black Brunswicker*
John Everett Millais, 1860

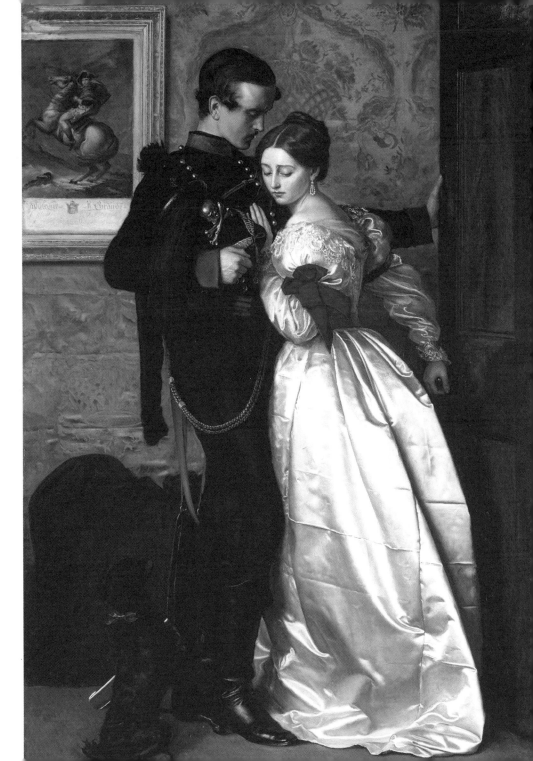

Georgiana Burne-Jones

1840–1920

If you had to name a family who had a sizeable cultural impact on Britain, the Macdonald family are strong contenders. Sisters Georgiana, Alice, Louisa and Agnes all married influential men and had notable children who changed the landscape of literature, art and architecture in this country. Alice married architect and designer John Lockwood Kipling, who assisted in the design of Queen Victoria's Durbar room at Osborne House, and did much to bring colonial talent and style back to England. He also provided illustrations to their son Rudyard Kipling's *The Jungle Book*. Agnes married artist and president of the Royal Academy, Edward Poynter, and Louisa married industrialist Alfred Baldwin, and their son Stanley became prime minister. Georgiana also married an artist, the Pre-Raphaelite follower Edward Burne-Jones, and thanks to her thorough and weighty *Memorials*, his contribution to Victorian art was never underestimated, even if hers would be.

Being the family of a Methodist minister meant the Macdonalds travelled around the country frequently, but finally when Georgiana, or 'Georgie' as she was known, was ten years old, the family settled in Birmingham where her brother Harry went to art school. Edward Burne-Jones was a friend of her brother's and as he had aspirations of entering the church, no doubt the Rev. Macdonald welcomed his presence in the house as a possible suitor for his daughter. However, he was poor, and abandoning the church for the life of an artist did not exactly improve his prospects. The couple

94

Georgiana Burne-Jones and 'Pip' (Philip) Burne-Jones
W. Jeffrey, c.1861

finally married in 1860 and had only £30 to their name, but marriage brought them happiness. They were close friends with other young Pre-Raphaelite couples, like Rossetti and Elizabeth Siddal, and spent time in William and Jane Morris's new home in Bexleyheath, decorating the walls with medieval-style murals. Georgie had also trained as an artist under Ford Madox Brown, and she was employed for some time by Morris and Co., painting decorative tiles.

Georgie gave up her work when she had children. She gave birth to Philip, later an artist like his father, in the autumn of 1861. In the summer of 1864, Philip caught scarlet fever,

Portrait of Georgiana Burne-Jones
Edward Poynter, c.1870

passing it to his pregnant mother. Georgie gave premature birth to their second son Christopher, who died soon afterwards. John Ruskin, who was fond of Georgie, arranged for the road outside the Burne-Jones's home to be covered in soft bark to muffle the noise of horses and carts so Georgie could rest. Their third child, Margaret, was born in 1866, and it was while Georgie was dedicating herself to the care of her children, that Burne-Jones brought scandal on the family by his affair with Maria Zambaco. In the *Memorials*, the years 1868–71 when the affair was raging, are alluded to with the lines 'Heart, thou and I here, sad and alone.' Despite his wanderings, Georgie forgave her husband, and he was to stray again, but somewhat more discretely, possibly learning that if he could not remain faithful at least he could refrain from being caught rolling in the street by the police (see Maria's pages for further scandalous details).

Despite being raised to the rank of 'Lady' Burne-Jones when her husband received a baronetcy, Georgie felt the need to work for the people, possibly as a result of her Methodist upbringing. She had become close friends with William Morris and a supporter of his work with the Socialist League, and she won a seat on a Parish Council, working for the rights of women

Portrait of Georgiana Burne-Jones
Edward Burne-Jones, 1863

and the working classes. Begun a few years before his death in 1898, Georgie published her two-volume *Memorials* of her husband in 1904, and continued to work on causes close to her heart, including making public anti-war statements at the time of the Boer conflict. She died aged eighty in 1920. Mother of an artist and grandmother to the novelists Angela Thirkell and Denis Mackail, Georgiana Burne-Jones may have been self-effacing of her own talents but tireless in her support of others.

MARIA ZAMBACO

Some women in history seem to come with a warning label. Their lives are far too passion-packed and self-involved, which seems to have been the case with Marie Terpsithea Cassavetti, otherwise known as the notorious Mrs Maria Zambaco, sculptor and homewrecker. Maria was such trouble that Georgiana Burne-Jones was forced to leave the years 1868-1871 out of her ever-so-thorough *Memorials* because Maria stole both her husband and the show. Broken marriages, suicide attempts and Oscar Wilde are all we tend to hear about Maria, but she had to have done something between lovers that would make her so fascinating.

Born in London to successful Anglo-Greek merchants, beautiful, titian-haired Maria must have always been far more ambitious than was decent for a girl. Testament to this is that at fifteen, on the death of her father, she became very wealthy and decided she did not need a chaperone anymore. She studied art at The Slade art school, followed by time in Paris, studying under Auguste Rodin. Her passion was sculpture, working

in terracotta and bronze, and she produced medallions, including one of her cousin Marie Spartali Stillman. She had no time for young men who tried to make her into a good Victorian wife, sending one besotted suitor, George du Maurier, away spurned and declaring she was 'rude and unapproachable but of great talent and a really wonderful beauty'. She married a man over a decade older than herself, Dr Demetrius Zambaco,

Maria Zambaco
Edward Burne-Jones, 1870

who was big in leprosy, but the marriage was not a success. After the birth of their two children the couple divorced, leaving Maria to return to her mother in London, ready to pursue her artistic career once more.

Maria's mother commissioned Edward Burne-Jones to paint her daughter and further her studies in art. After studying under many great men in the art world, Maria took her relationship with Burne-Jones further and the couple started an affair which proved as disastrous as it was passionate. Maria demanded that Burne-Jones left his wife, to run away with her to a little Greek island for just the two of them. Burne-Jones lacked the courage to do this, and so in a last-ditch attempt to possess him fully, Maria proposed joint suicide by poison. When Burne-Jones refused, she attempted to throw herself in the canal. His attempts to stop her drew a crowd and as the couple wrestled on the pavement the police arrived....

A subsequent problem was that she had possessed his imagination for three years and all of his paintings bore her likeness. The painting he displayed the year after the incident by the canal showed the Greek myth of 'Phyllis and Demophoon' with Phyllis erupting from a tree to seize her frenzied and terrified lover. The gossip alone made it a scandalous picture that was removed by the artist

The Love Song
Edward Burne-Jones, 1868-77

after the gallery requested he cover up Demophoon's bits and pieces.

By now polite society was finding Mrs Zambaco too much to handle, snubbing her with such ferocity that Maria removed herself permanently to Paris, where she met Oscar Wilde who had been enchanted by her since seeing Burne-Jones's art. He described her as 'beautiful and subtle … like a snake'. Much gossip continued back in London about the terrible Mrs Zambaco and her lovers but what no one suspected was that Burne-Jones continued to pursue his muse, both in Paris and back in London where the couple kept adjoining studios. However much it was denied, Maria's face haunts Burne-Jones's paintings until his death. Maria retired back to Paris and died there in obscurity in 1914.

Opposite – *The Tree of Forgiveness*
Edward Burne-Jones, 1882

Overleaf – *Love Amongst the Ruins*
Edward Burne-Jones, c.1873

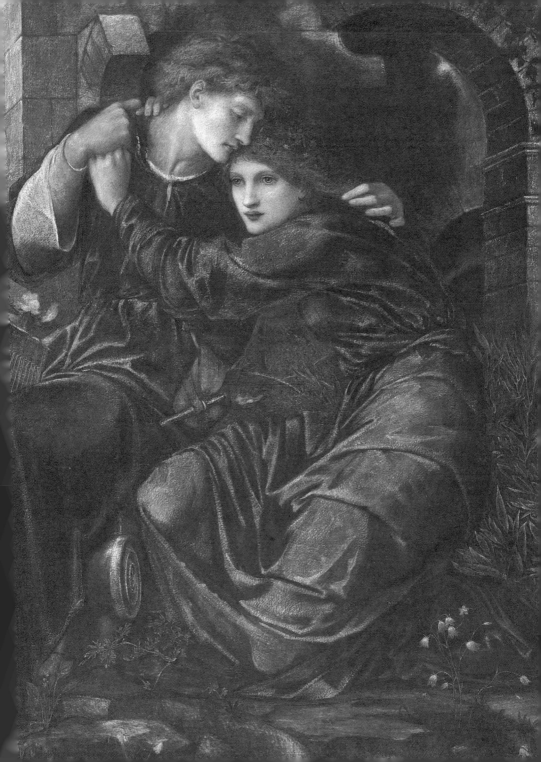

Emma Sandys

1843-1877

Being a member of an artistic family, you would think it would have been easier for Emma Sandys to make her mark. No doubt she was fully supported both by her portrait-painter father and her Pre-Raphaelite brother, Frederick, but somehow over time Emma has been lost in the shadows.

Emma and Frederick were taught to paint by their father, her brother taking off to spurious notoriety in London among the Bohemian set. He met John Everett Millais at the Society of Art exhibition in 1847 and later befriended the other Pre-Raphaelites, developing a special bond with Dante Gabriel Rossetti. Emma stayed back in Norfolk to develop her career, carving a successful path of portraits, especially those of children. Her brother's enthusiasm for the Pre-Raphaelite style rubbed off on Emma who perfected her paintings of princesses draped in luxurious fabrics and strings of pearls and amber.

Her work became admired at the Royal Academy, and she made a move to London in the early

A Fashionable Lady
Emma Sandys, c.1870

1870s. This might have only been for a brief time, sharing a studio with her brother. It is thought that they shared props and costumes, cloaks and shells, in their works that were so similar in tone that many of Emma's works have been misidentified as her brother's paintings. It is also thought that she acted as her brother's studio assistant during this time, learning and perfecting her own skills and producing delicately featured, jewel-bright, dream-like beauties, resplendent in flowers.

Even though she was selling paintings, Emma did not describe herself as an artist on the census returns. Her work was proving successful and was bought by local collectors. Unfortunately, her reputation was forever overshadowed by that of her brother and his scandalous behaviour, which always roused more interest than her quiet and modest demeanour.

Her professional career lasted just over a decade, and Emma died aged only thirty-four from lung congestion at her home, Grapes Hill, in Norwich.

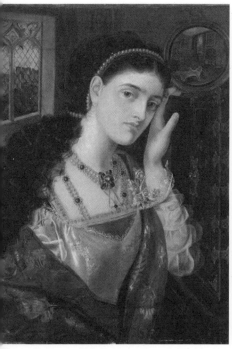

Viola
Emma Sandys, n.d

Preparing for the Ball
Emma Sandys, 1867

Opposite – *Fiammetta*
Emma Sandys, 1876

Louise Jopling
1843-1933

Louise Goode's start in life was not promising. One of nine siblings, both her parents died whilst she was still a child. When Louise married civil servant and compulsive gambler, Frank Romer, at the age of seventeen, society dictated that she relinquish any ambition she might have had to become anything other than a wife and mother. Luckily for budding artist Louise, her husband showed some of her sketches to family friend Baroness

de Rothschild, of the famous banking family, who recognised her talent and encouraged her to pursue her creative potential. In unconventional style, Louise was able to travel to France to study and exhibit in the prestigious Salon. By

1870, despite juggling motherhood and her artistic career, Louise was ready to show at the Royal Academy. Unfortunately, her husband's fortunes were not so rosy and the de Rothschilds sacked him due to his gambling.

Louise's success was not popular at home and her husband deserted her, threatening to seize her paintings. But in 1872 Frank died, and Louise plunged herself further into her art, continuing to exhibit and building both a reputation and a list of wealthy and influential patrons who wished to pose for a portrait. She married fellow artist Joseph Middleton Jopling in 1874 and changed her professional name to Louise Jopling. Her experiences in her first marriage had left a mark, further complicated by the death of all but one of her children in infancy, but she remained realistic about her chances as a mother and a working artist: 'I would be loading myself with extra duties, and all these duties would be as iron bars to my success ... the best thing I can do for my reputation's sake, and my boy's is to marry again.'

Self-portrait No 2 in Red
Louise Jopling, 1875–78

Louise was part of a wide and influential social circle. Her friends and clients included Oscar Wilde, Ellen Terry, Lillie Langtry and Kate Perugini, and her own portrait was painted by James Abbott McNeill Whistler and John Everett Millais, whose portrait of 1879 became a sensation when it was exhibited in the Grosvenor Gallery. Her own artistic success followed with exhibitions in Paris and Philadelphia, and soon she was earning more money than her husband but still the inequality between male and female artists held her back. In 1883, as a famous and respected portraitist she applied for a commission of a woman's portrait at a price of 150 guineas but lost the job to her old friend Millais, who charged 1,000 guineas for the piece.

When once more widowed in 1884, Louise married for the third time but continued to use the name 'Jopling' professionally. She rented out her late husband's studio to Maria Zambaco, close to that of Maria's lover Edward Burne-Jones. Frustrated by the obstacles placed in the way of female artists, she established her own school of art for women and wrote several articles and a book on the subject. Her school allowed women the equal right to men to study male nudes, not allowed at the official Royal Academy school. She was an active feminist and suffragist, and served as vice-president of the Healthy and Artistic Dress Union, requesting dress reform at the end of the nineteenth century. Louise was the first woman to be admitted to the Royal Society of British Artists in 1901. She wrote her memoir, *Twenty Years of My Life, 1867–1887*, in 1925, and expressed her anger at the gender expectations that had dogged her professional life: 'I hate being a woman,' she wrote, 'Women never do anything.' She died in 1933, a few days after her ninetieth birthday.

ST. BRIDGET, FROM A PHOTOGRAPH BY R. J. W. HAINES

Mrs. Louise Jopling, R.B.A., Painter

Saint Bridget
Louise Jopling, 1905

Opposite – *Blue and White*
Louise Jopling, 1896

LUCY MADOX BROWN
1843–1894

When Lucy's mother died three years after she was born, she was left in the care of her father, artist Ford Madox Brown. He sketched her frequently and recorded how she both brought him comfort and gave him a reason to continue. However, he was unable to work and look after her, so Lucy was sent to live with her mother's family but frequently saw her father and his new wife, Emma. She moved to the Rossetti household when she was ten, possibly to protect her from Emma's drinking, and was tutored by Maria, sister of Pre-Raphaelite artist Dante Gabriel and her future husband William Michael. It is unsurprising, being surrounded by so much art, that Lucy's ambition was to become an artist like her father, and a trip to the Art Treasures Exhibition when she was 13 fixed her in this purpose.

When Ford Madox Brown's assistant left, Lucy returned to her father's studio not as a model but as both secretary and studio assistant. In return, he taught her to paint with Marie Spartali Stillman, in the same studio he had taught Georgiana Burne-Jones a decade before. Lucy exhibited her first picture, entitled *Painting* at the Dudley Gallery in London in 1869, receiving the approval of the critics. Further success was found with *After the Ball* (1870) and *Ferdinand and Miranda Playing Chess* (1871), both examples of Pre-Raphaelite-styled figures, painted in watercolour. In 1870, her painting *The Duet* was received warmly at the Royal Academy and

112

Lucy Madox Brown
Ford Madox Brown, 1849

the year after, she exhibited her most famous work, *Romeo and Juliet*, sealing her reputation as artist of connections equal to her talent. All of her work showed the marked influence of her father and her love of Pre-Raphaelite subjects from literature and history. She travelled in Europe with William and Jane Morris, and later in Italy with William Michael Rossetti, who proposed to her on the journey home.

In 1874, she stopped painting and married William. There was a sizable age gap between the two but they shared an interest in feminism, politics and atheism, which was at odds with his religious mother and sisters. Lucy was a signatory of the national petition for women's suffrage, and her younger sister Catherine Madox Brown said of her that she had a violent temper and a strong brain. The couple had five children, four of whom survived infancy. Her daughters Helen Rossetti Angeli went on to write about Pre-Raphaelitism and her family, and Olivia Rossetti Agresti became a political anarchistic linked to Italian fascism.

After her marriage, Lucy concentrated on her children and turned to writing. She wrote a biography of Mary Shelley for John Ingram's 'Eminent Women' series in 1890, and an unpublished biography of her father. Her health began to suffer in 1885 when she developed tuberculosis, the disease that had killed her mother, and she had to spend the winters in Italy. She died there in 1894, having changed her will so that all her money was left to her children, possibly to protect them in the event that William Michael remarried.

The Duet
Lucy Madox Brown, 1870

Ferdinand and Miranda Playing Chess
Lucy Madox Brown, 1871

SOPHIA GRAY

1843 – 1882

Sophia Gray, more commonly known as Sophy, was the tenth child of the Gray family. She was the much younger sister of Euphemia, better known as Effie. Sophy was only five at the time of her sister's union with John Ruskin and went to live with the unhappy couple in the last years of their marriage. Aged only eleven, Sophy accompanied her sister as she left Ruskin's home and the scandalous annulment commenced.

Caught in the middle, Sophy not only acted as a go-between for her sister and new suitor John Everett Millais, but was also spoiled and indulged by the Ruskin family. Her sister's soon-to-be ex-husband took walks with Sophy, putting his side of the story and trying to win her round with whispers of malice against Effie. Whilst Effie was escaping her unhappy life with the Ruskins for her new life with Millais, Sophy seemed trapped trying to please everyone. During this period, Millais painted a defiant portrait of fourteen-year-old Sophy, looking so strikingly attractive that

George Price Boyce bought the portrait to hang beside *Bocca Baciata* (1859) by Dante Gabriel Rossetti, an overtly sexual portrait of his mistress, Fanny Cornforth.

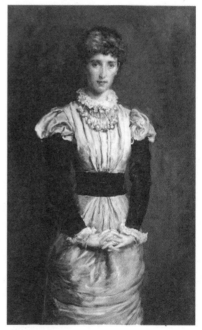

Sophy Caird
John Everett Millais, 1880

Millais also used Sophy in *Autumn Leaves* (1855–6) and *Spring (Apple Blossom)* (1859), and produced other

images of his young sister-in-law, but the turmoil of the relationships around her left its mark. Sophy became ill, her mental and physical state deteriorating together as she grew anorexic and 'hysterical'. Sophy received extensive treatment from specialists in lunacy, and her behaviour and health caused her family and friends concern. Unlike her peers who would have been married off as young, eligible women, Sophy, damaged by her experiences, did not marry until she was thirty. She wed James Caird, a jute manufacturer from Dundee who had waited for her to regain her health, but the marriage was not a success. She gave birth to a daughter, Beatrix, the following year, but the couple grew distant as her husband had little time or patience for Sophy's health issues.

In 1880, Millais painted a final portrait of his sister-in-law. In marked contrast to the precocious, wild-spirited child, thirty-six-year-old Sophy looked slight and timid. She died in 1882, aged only thirty-eight. The cause of death was given as exhaustion and atrophy of the nervous system over seventeen years. Little Beatrix Caird died only six years after her mother in 1888, aged only fourteen, the same age as Sophy had been when Millais painted the defining, defiant image of her.

Sophie Grey
Charles Edward Perugini, c.1880

Opposite – *Autumn Leaves*
John Everett Millais, 1855-6

Marie Spartali Stillman

1844-1927

Eldest daughter of a Greek merchant and cousin to fellow artists Maria Zambaco and Aglaia Ionides, Marie Spartali Stillman had a privileged start in life. The family had a large house on Clapham Common called 'The Shrubbery' with views over Chelsea, and in the summer they lived on the Isle of Wight where her father grew grapes. At a party in a family member's house, Marie, dressed in white with a blue sash, met the up-and-coming artists and writers of the time, including the poet Algernon Swinburne, who declared after meeting Marie, 'She is so beautiful that I want to sit down and cry.'

She studied art under Ford Madox Brown for six years, developing into an artist of obvious Pre-Raphaelite leanings. However, the artists she mixed with only wanted to talk about how beautiful she was. Dante Gabriel Rossetti wrote to his friend Madox Brown, eager to get access to Marie, 'I just hear Miss Spartali is to be your pupil. I hear too that she is one and the same with a marvellous beauty of whom I have heard much talk. So box her up and don't let fellows see her, as I mean to have first shy at her in the way

A Rose from Armida's Garden
Marie Spartali Stillman, 1894

of sitting.' Being tall and beautiful, Marie struggled to be taken seriously by the other artists to start with and even Madox Brown became infatuated with her. She modelled for Rossetti, Edward Burne-Jones and Julia Margaret Cameron, a neighbour on the Isle of Wight. All the time, Marie's art grew in confidence. She painted typically Pre-Raphaelite women in costume but her style was her own. She drew on subjects from history and from Shakespeare, heroines in love and loss, in chalk and watercolour.

Marie Spartali
Julia Margaret Cameron, 1867-8

Marie had a torrid affair with the notorious Lord Ranelagh, known in society as a bit of a womaniser and obviously not the sort that Mr Spartali wanted his daughter to marry, and so their connection was broken off. Marie's parents weren't so successful in ending the next seemingly unsuitable relationship,

this time with an American widower and writer, William Stillman. His first wife had committed suicide, leaving him to raise their children while travelling with his work as a journalist, critic and photographer. He had posed for Rossetti in a painting entitled *Dante's Dream* (around 1871), which also featured Marie, and the couple had met and fallen in love. Against her family's wishes, Marie married him in 1871.

William's job as a foreign correspondent saw them move to Italy and travel in America, where she painted and exhibited on the East Coast. Despite the roaming nature of her family life, she was a regular contributor to the Grosvenor Gallery and its successor, The New Gallery, but although her work was popular, it didn't seem to sell in the shows.

When she died, Marie left a note with her Will that she had nothing of great interest to leave. Today, however, her works are numbered in some of the great Pre-Raphaelite collections in the world and her body of work is valued at many millions of pounds. In her obituary in *The Times*, in 1927, it was written 'With the great triad of those early and now remote days, Mrs Rossetti, Lady Burne-Jones, and Mrs Morris, she was almost a fourth, and of the two latter was a lifelong friend.'

Opposite – *A Vision of Fiammetta*
Dante Gabriel Rossetti, 1878

Overleaf – *Dante's Dream*
Dante Gabriel Rossetti, c.1871

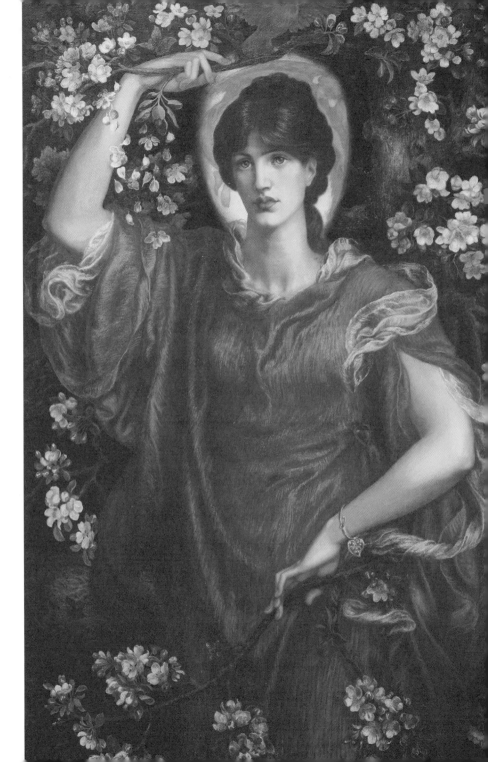

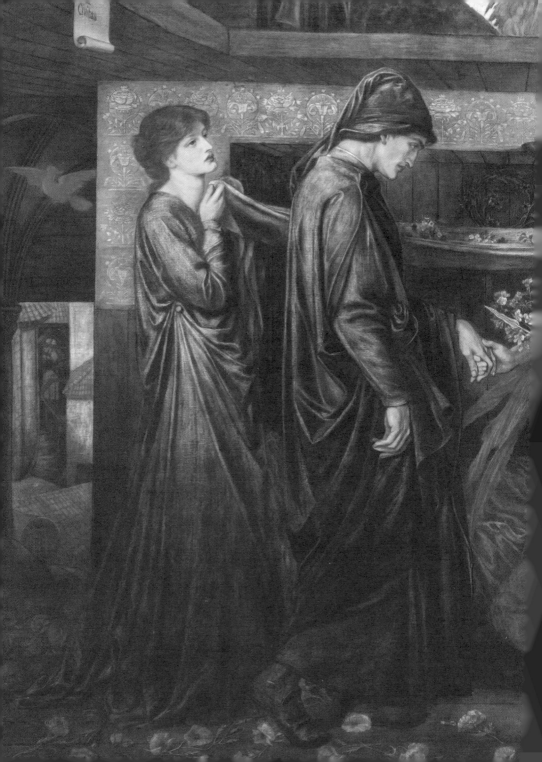

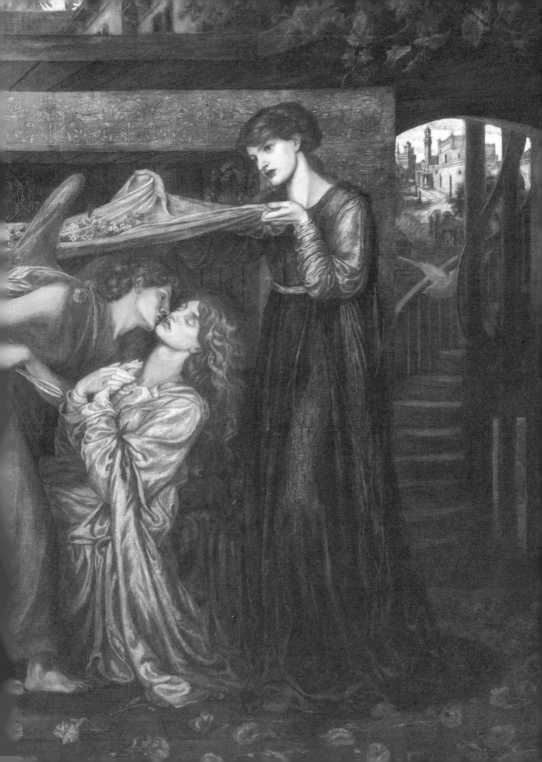

Anna Lea Merritt
1844-1930

Born in Philadelphia, the eldest of six sisters in a wealthy Quaker family, Anna Lea Merritt's first brush with Pre-Raphaelitism was a visit to a touring exhibition that came to her hometown when she was a child. Seeing William Holman Hunt's *Light of the World* decided her on a path to becoming an artist, but at that time the American colleges didn't allow women to study art. Being a resourceful woman, Anna enrolled in a women's medical college so she could sneakily draw the bodies she studied.

The family moved to mainland Europe in 1865 and then from there to London in order to avoid the Franco-Prussian war. Anna took up her studies once more, this time with the artist and critic Henry Merritt as her tutor. Despite an age gap of over twenty years, the couple fell in love and married in April 1877. Tragically, he died before the autumn of the same year.

In Henry's memory, Anna painted her best-known picture, *Love*

Locked Out (1890), showing the figure of Love waiting at a door to be let in, symbolising how she would have to wait until death to be reunited with her husband. It struck an emotional chord with many people who, like Anna, had been parted from loved ones too soon. Not only that, it was taken as a symbol of forbidden love, and of society barring the path of true love. It was the first painting by a woman to be bought for a national collection and still hangs in Tate Britain today.

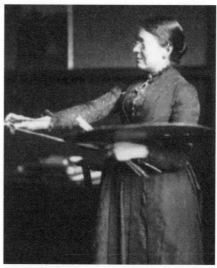

Anna Lea Merritt
Frederick Hollyer, 1886

Teaching herself to etch, Anna produced a double volume of Henry's art criticism, which she illustrated. She was also asked by the editor of the *Etcher* journal to etch a picture of Ellen Terry as Ophelia, a role with which she had tremendous success. Anna wrote many articles and books on art, gardening and the village in which she lived. She wrote that the main obstacle that stopped women artists from achieving the fame of male artists was that they didn't have a wife doing all the work in the house!

Although her art was popular, it wasn't without scandal. When, in 1885, she exhibited *Eve*, the nude figure caused an uproar as women were not meant to have access to adult nude models. Anna never painted another adult nude, using children instead, as in *Love Locked Out*.

Anna lived on Tite Street in London, which was famous for its artists and writers. Her neighbours included Oscar Wilde, James Whistler, John Singer Sargent and James Collier. She had little time for Whistler and his aestheticism. When they met at a dinner party, Whistler, who wore a monocle as an affectation, said he liked Anna's little glasses. 'Mine are for looking,' said Anna, 'Yours are for looks....' implying that his art, much like his monocle, was style over substance.

Eventually, Anna turned her back on London and spent the rest of her life in the small Hampshire village of Hurstbourne Tarrant, writing and painting in peaceful solitude.

Ophelia
Anna Lea Merritt, 1880

When Anna died, Edith Holman Hunt wrote a brief obituary to *The Times*. She described how Anna had nursed her, fifty years previously, during an illness in Cairo. Anna had lost her sight in later life, and Edith wrote 'She had a heart of gold, never complaining of her blindness.'

Opposite – *Love Locked Out*
Anna Lea Merritt, 1890

ELLEN SMITH
1844–1889

Some women spend their lives in pursuit of Pre-Raphaelite beauty, but for some it is only an ephemeral flicker of light, a brief moment of glory. This was the case for little Ellen Smith, the unlucky laundress.

In the mid-1860s, Dante Gabriel Rossetti was finding it hard to sell his paintings. He had been using the face of his mistress, Fanny Cornforth, since the death of Elizabeth Siddal in 1862, but somehow the magic wasn't happening. Patrons were not calling and some of his most beautiful canvases were being politely refused. He needed another model. This led him to abduct Alexa Wilding from the street in order to reignite his creative juices, if you excuse the expression, but before Alexa, for a little while, came Ellen.

Born near where Millais painted the stream for *Ophelia* (1852) in Surrey, Ellen had moved to London with her family to find work. She was working as a waitress when, in around 1863, Rossetti approached her in the street to model for him. Being small, delicate and dark haired, she was the perfect contrast to the strapping, blonde Fanny Cornforth, and Ellen, in search of easier work, agreed.

She was soon much in demand, modelling for other artists including Simeon Solomon, Edward Burne-Jones, Edward Poynter, and John Roddam Spencer Stanhope. Rossetti gave George Price Boyce a gift of a sketch of Ellen as one of the bridesmaids in his painting

Joli Coeur
Dante Gabriel Rossetti, 1867

The Beloved (1865–6), and Boyce fell in love with her, although it must be mentioned he seems to have fallen in love with every pretty girl he saw. He paid her to pose for him too.

The first of Ellen's misfortunes struck in the form of rheumatism. It became painful for her to keep a pose for a long time and Boyce records in his diary how some days she arrived looking very unwell. Being a kind-hearted man, especially when it came to pretty girls, Boyce bought Ellen a pure alpaca wool dress to keep her warm and ease her symptoms. Fanny Cornforth went one step further and visited all the artists who had used Ellen as a model, collecting 'sick pay' from them in order to make sure Ellen remained fed and housed when she couldn't work.

Between the modelling and a loan from Boyce, Ellen saved enough money to buy her own laundry business and her future was looking rosy. Tragically, there was someone who was not pleased with Ellen's success. In 1870, a soldier who had become obsessed with her grew so jealous he attacked her with a knife, scarring her face so badly that she would never model again.

Ellen was not finished, as she had her laundry and found solace in the arms of a childhood friend, a cabbie named Fred Elson, whom she married in 1873. She kept in touch with her former Pre-Raphaelite friends who became customers of her laundry, but her life was not a long one. She died aged only forty-five, in 1889.

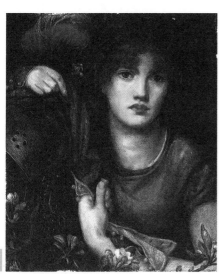

My Lady Greensleeves
Dante Gabriel Rossetti, 1863

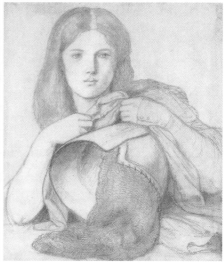

Study for My Lady Greensleeves
Dante Gabriel Rossetti, c.1860-3

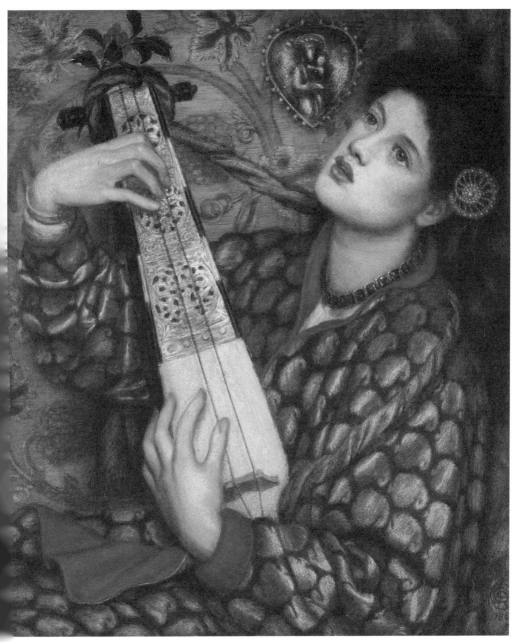

A Christmas Carol
Dante Gabriel Rossetti, 1867

Annie Louisa Swynnerton

1844-1933

Daughter of a Manchester solicitor, Annie was one of three artists in her family. Her sisters Emily and Julia both trained and worked as painters and all three of them were founder members of the Manchester Society of Women Painters. However, Annie was the one who found the most success.

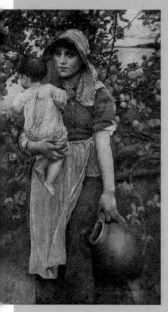

When the family went through a period of financial difficulty, Annie started selling her watercolours. Her works were so popular that the family was soon back in the black and whilst studying at the Manchester School of Art, she won a gold prize and scholarship.

Together with fellow artist and suffragette Isabel Dacre, Annie went to study in Rome and then Paris. Whilst in Rome, Annie made the acquaintance of a sculptor called Joseph Swynnerton, with whom she kept in touch even after her return to Manchester.

It was on their return from Paris that Annie, her sisters and Isabel formed the Society of Women Painters. Isabel was the president, Annie served as secretary and Emily was treasurer. The Society held annual exhibitions which were described in the local press as 'one of the most pleasing events in the artistic year in Manchester'. In the Society's 1882 exhibition, Isabel exhibited a three-quarter-length portrait of Annie. The Society provided a location and facilities for the members to work together and study from life. At this time it was difficult for women to have access to nude models, and many canvases featuring

The Young Mother
Annie Swynnerton, c.1887

Illusions
Annie Swynnerton, c.1900

nude adults by female artists were often condemned by critics, which frustrated many women painters.

In the summer of 1883, Annie and Swynnerton married and returned to Rome where they lived until his death in 1910, although Annie returned to England to exhibit her paintings on a regular basis. During this period Annie became active in the suffrage campaign. In 1889, Annie signed the declaration in favour of women's suffrage and in 1897 she signed the claim for women's suffrage. In 1895, Annie was only the second woman ever to be invited to sit on the hanging committee of the Liverpool Autumn Exhibition. Her painting, *Oreads*, of 1907, was acquired by John Singer Sargent, a great admirer of her work, and he helped her to become the first elected ARA in 1922. Annie also headed the section of Chelsea artists in the coronation procession of George V in 1911, organised by the women's suffrage societies.

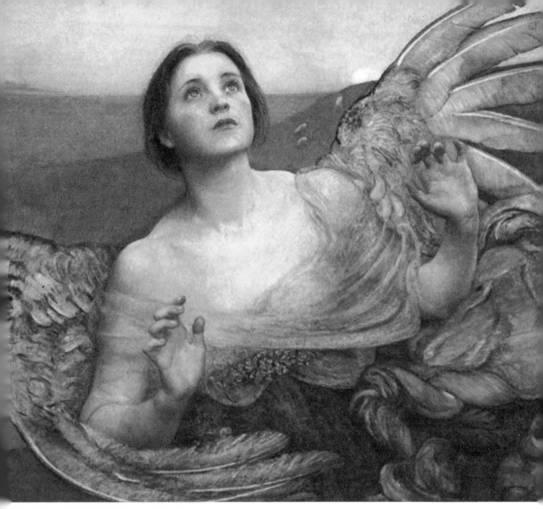

The Sense of Sight
Annie Swynnerton, 1895

As an older woman, Annie's eyesight began to fail but she was remembered by younger artists such as Laura Knight as a formidable and somewhat eccentric woman, who was talented and accomplished but so full of the courage of her convictions that she could be outspoken. She moved out of London to the south coast for her health and died there in 1933, aged eighty-nine, leaving a studio full of 170 paintings, all but a dozen of them finished and framed. She is buried in the local graveyard with a gravestone that reads 'I have known love and the light of the sun'.

MARY EMMA JONES

Born in Hull, Mary Jones and her family moved down to London in the 1860s in search of culture and opportunities. Mary and her sisters had aspirations to be artists' models and actresses, and managed to accomplish this desire very well indeed. Sisters Equity, Augusta and Emelie all modelled for James Abbott McNeill Whistler and Edward Burne-Jones, but Mary went one step further and actually set up home with Pre-Raphaelite artist, Frederick Sandys.

It was probably whilst touring in a play in Norfolk that Mary, also known by her stage name 'Miss Clive', met Sandys. In 1862 she sat for his painting *Mary Magdalene* but then she vanished from his life as quickly as she had appeared. Mary continued to pursue her acting career in provincial plays while Sandys attempted to divorce his first wife while setting up home with his Romany mistress, Keomi. It wasn't until 1866, and probably back in London, that Mary re-entered Sandys life, this time with her sisters who all modelled for him and others in the Pre-Raphaelite circle. Whilst Equity, Augusta and

Emelie posed for a number of different artists, Mary just had eyes for Frederick Sandys and appeared in a string of lush, sensuous canvases, including *Love's Shadow* (1867) and *Proud Maisie* (1868), the last of which proved so popular he had made eleven copies of it by the time of his death. Among the Pre-Raphaelite circle she was known as Sandys's 'little girl', and despite his affair with Keomi not ending until 1868, in 1867 Mary gave birth to their first child.

She was almost a star of the stage. The Queen's Theatre in London spread

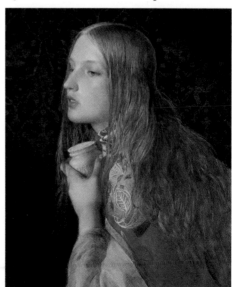

Mary Magdalene
Frederick Sandys, c.1858-60

the word about the brilliant 'Miss Clive' who would make her debut on the London stage in their 1873 play *King John*, and was rumoured to be paying her a fortune and supplying all her gowns. However, the critics were somewhat underwhelmed with her performance. Not only that, Mary was struck down with rheumatic fever during the run, and Sandys whisked her back to Norfolk to nurse her in his parents' home. She recovered and occasionally performed, but between modelling and giving birth to their ten children, Mary's dramatics were limited to her domestic audience.

Mary brought her children up on Shakespeare and elocution lessons, and their father taught them art. Their daughter Winifred became a successful artist in her own right. After Sandys's death in 1904, Mary organised her children into a cottage industry to produce arts and crafts they could sell to support the household. She was remembered by her grandchildren as an affectionate but powerful personality, dressed in black Victorian mourning. After her death in 1920, the poet and Pre-Raphaelite collector Gordon Bottomley remembered her in a poem published in the newspapers:

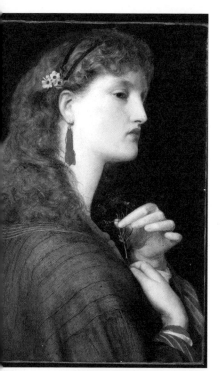

Mary Sandys September 12 1920
by Gordon Bottomley

In a great time of vision and poetry
She spoke with great men every day and lived
For them to praise her face and praise her hair
And all her spirit and pride; and one she loved
Who celebrated the marvelousness of her
In lines and hues as lovely as her own.
In Helen Rosamund, Penelope, Hero
He found her: he renewed their life by hers,
Adding her tense, immortal looks to them.
Youth and that passionate great hour flew fast
Burdens and griefs that loveliness should not bear
Were borne by her: these, too, are at an end,
Vision and poetry her treasures still.
But her proud beauty is not at an end
Now she is deathless by her lover's hand,
To move our hearts and those of men not born,
With famous ladies by her living hair —
Helen and Rosamund and Mary Sandys.

May Margaret
Anthony Frederick Sandys, 1867

Opposite – *Love's Shadow*
Anthony Frederick Sandys, 1867

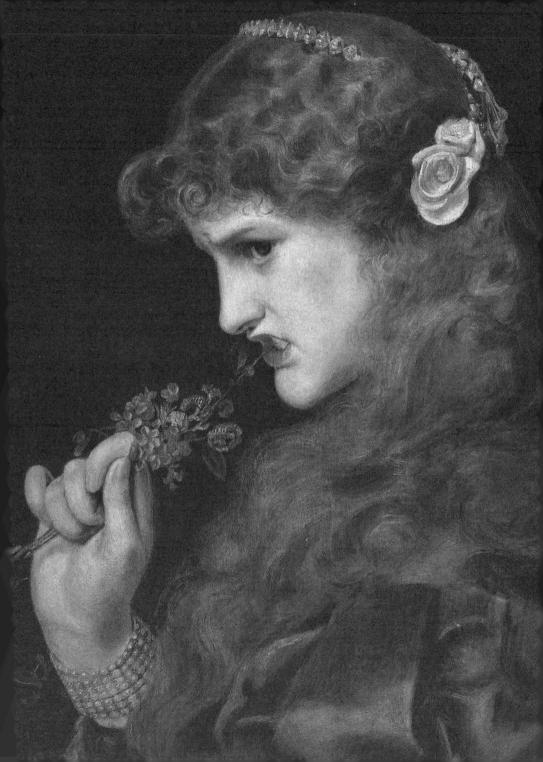

Julia Prinsep Jackson
1846-1895

Some girls are born into creative families and therefore destined to make their mark on the artistic world. Julia Jackson was surrounded by artists and writers from early in her life; born into a British colonial family in India, Julia and her mother and sisters returned to London for their health when she was a toddler. They lived in Little Holland House in London, famed for the gatherings of painters and authors, and Julia's social circle was wide and influential not only in the world of art and literature, but also in politics and philosophy, including figures such as Benjamin Disraeli and Thomas Carlyle. Julia grew into a celebrated beauty and received marriage proposals from William Holman Hunt and Thomas Woolner when she was eighteen, but refused them and many other offers of courtship from artists, marrying Herbert Duckworth, a barrister, three years later.

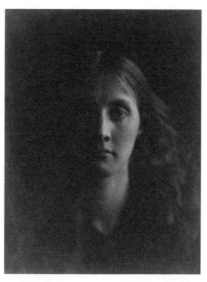

Her aunt, Julia Margaret Cameron, used her for many portraits, starting when she was a young woman, through her marriage at twenty-one, which Cameron saw as marking the transition from girlhood to womanhood. Duckworth tragically died aged thirty-seven, leaving Julia to raise her children as a young widow at only twenty-four, heavily pregnant with their third child who was born less than two months after his father's death. Duckworth's death left her very depressed and she would lie on his grave, sobbing, but knew she had to

Julia Jackson
Julia Margaret Cameron, 1867

carry on her life for the sake of her children. She found comfort in tending to the sick and wrote a book about her experiences, *Notes from Sick Rooms* (1883), which served as an instruction manual. She also wrote a book of children's stories, emphasising the importance of family life, a subject close to her heart.

She moved to the Isle of Wight to be with her parents and her Aunt Julia, and there met her second husband, Leslie Stephen, the first editor of the *Dictionary of National Biography*, for which Julia wrote the entry for Julia Margaret Cameron, one of the few entries for women at that time. Leslie had also been widowed young. His wife had died in childbirth, leaving him with a baby to raise. He and Julia became close in their understanding of each other's grief. After eight years of mourning for her first husband, Julia and Stephen became engaged and married, restarting Julia's life in society once more. She even returned to modelling for friends and family, including posing for Edward Burne-Jones's image of the Annunciation, whilst pregnant. Julia and Stephen

The Annunciation
Edward Burne-Jones, 1879

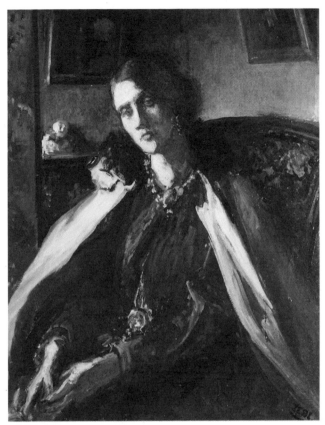

Julia Stephen
Jacques-Emile Blanche, n.d.

had four children, including the painter Vanessa Bell and the feminist writer Virginia Woolf. Despite being wealthy, Julia wanted to care for people and worked in hospitals and workhouses, writing about her experiences and championing women like Florence Nightingale as role models for girls. Despite not being a supporter of suffrage, she wrote an essay about the strength of sisterhood and women's rights in all other matters. Her powerful personality and early death at the age of forty-nine was to have a lasting effect on her daughters, through Virginia's writing and Vanessa's art, and her beauty lives on through the work of her aunt. For a woman who is often referred to as an 'anti-feminist', Julia Jackson did much to further the work of the women who surrounded her.

Alexa Wilding

1847-1884

Despite being one of the most recognisable faces of Pre-Raphaelite art, we know precious little about the life of the model known as Alexa Wilding. Her face graces more finished canvases than any of Dante Gabriel Rossetti's other models, yet her origins and carrying-ons are still shrouded in mystery. What we know leaves tantalising clues about the woman herself and the life of a model.

'Alexa' was born plain Alice Wilding but adopted the more glamorous name in the hope of a life on the stage. She lived behind St Paul's Cathedral and Newgate Prison with her butcher uncles and grandmother in less than salubrious, ramshackle slums. When she was old enough, Alexa was sent out to earn her keep, working long hours as a dressmaker. One evening in the spring of 1865, she was walking home after a long day of sewing when she was accosted by Rossetti who declared her the most beautiful woman he had ever

seen and just what he needed for his art. In truth, Rossetti had found himself in a bit of a slump; the face of his mistress Fanny Cornforth was no longer shifting art and he needed a fresh face to bring back his patrons. Alexa's angular, sphinx-like face and icy beauty was exactly what was required to balance out the sensuality of his subjects. Alexa agreed to attend his studio but for one reason or another did not visit the next day and vanished from Rossetti's life for another six months. The next time Rossetti saw Alexa he was not about to make the same mistake again. He grabbed her from the street and carried her off in his carriage to his home in Chelsea.

It is rather telling that even though Rossetti's extreme actions, probably driven by desperation, were tantamount to abduction, Alexa accepted his proposition to become his exclusive model. In return, Rossetti paid her a generous

Study for 'Dante's Dream':
Head of Alexa Wilding
Dante Gabriel Rossetti, 1870

dozen women, none of them wholly
fulfilling Rossetti's vision of the piece.

It is because Rossetti began to
rely very heavily on Alexa that her
absences, often without warning,
caused him irritation. He would
write frustrated letters to his friends
to see if they knew where she was
and how annoyed he was at her
flightiness. Apparently, he never
suspected that Alexa, unmarried and
seemingly unattached, was off giving
birth to her three children, who
all lived with her in a rather grand
house she owned in Kensington.
How she managed to acquire the
house on her model's wage and
who the father of the children was
is entirely shrouded in mystery. It
wouldn't be out of character for
Rossetti to be romantically entangled
with his models (which he often
was) but in that case he would have
known about the children. Also, he
was in no position to pay for a house
for his secret family as he was already
renting a house for his less-than-
secret mistress, Fanny Cornforth, just
around the corner from his official
residence on Cheyne Walk. Rossetti

weekly wage, whether he needed her
services or not. Alexa's face paid off,
as Rossetti gained the patronage of
rich men who found her cool beauty
exactly their cup of tea. Rossetti
even went so far as to scrape Fanny
Cornforth's face out of *Lady Lilith*
(1865) and replace it with Alexa's.
Like his lucky charm, she enabled
him to finish canvases such as *Venus
Verticordia* (begun 1863), which had
been started from around half a

The Bower Meadow
Dante Gabriel Rossetti, 1872

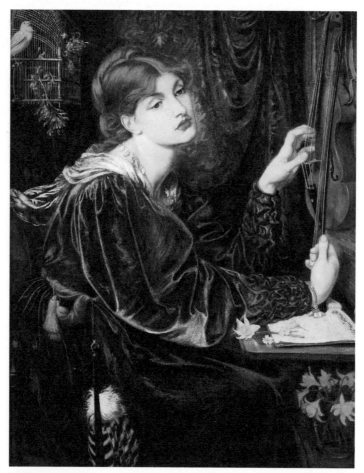

Veronica Veronese
Dante Gabriel Rossetti, 1872

also made a joke of how stupid Alexa was, neither 'gifted nor amusing', and he wished he could place her in a cupboard when he wasn't painting her. However, in keeping her family and connections a secret Alexa managed to outsmart Rossetti and his legion of biographers.

When Rossetti died in 1882, Alexa was one of the few models who attended the funeral and then made frequent visits to the grave in Kent, despite her own ill health. She died of peritonitis two years after Rossetti, aged only thirty-seven.

Opposite – *A Sea Spell*
Dante Gabriel Rossetti, 1877

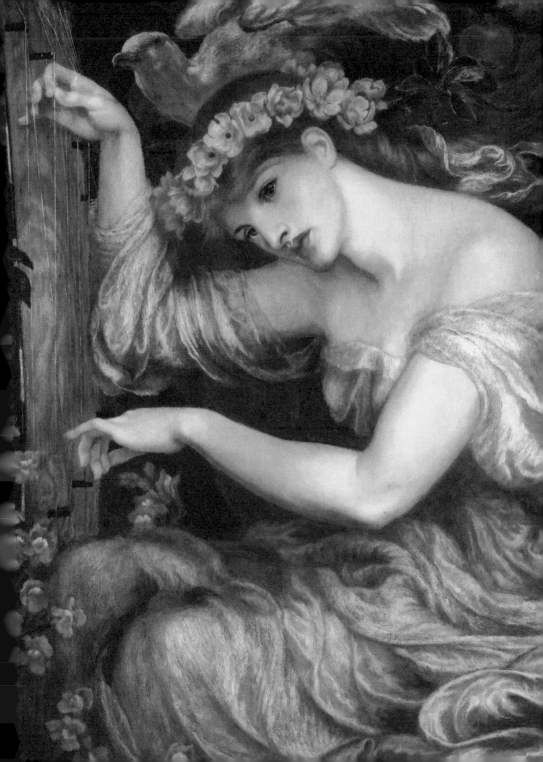

ELLEN TERRY
1847–1928

Dame Alice Ellen Terry's first memory was sitting alone in a rented room waiting for her mother, father and sister to come home. She was less than five years old at the time and already impatient to be on stage with her family, night after night. She got her wish four years later in *The Winter's Tale*, which she performed, aged nine, without an understudy, for over one hundred nights.

Ellen didn't attend school, being taught backstage and between performances by her parents. Her elder sister, Kate, was more famous when they were younger and George Frederic Watts was commissioned to paint the siblings. He was in his forties and Ellen was barely sixteen but something about the glamour of his studio and his social circle drew her to him. He was being pressured to marry and it must have been tempting to marry someone who could double as a model. Although the reasons seemed to be anything but love, the couple wed.

Watts took his young bride to Freshwater on the Isle of Wight to meet his friends. There, Julia Margaret Cameron took photographs of Ellen, entitled *Sadness* (1864), showing the girl looking mournful, leaning against Lord Tennyson's bathroom wall at Farringford. If that wasn't foreboding enough, Watts chose to portray his young bride as a fickle, easily led girl drawn to the showy

Ellen Terry at Age Sixteen
Julia Margaret Cameron, 1864

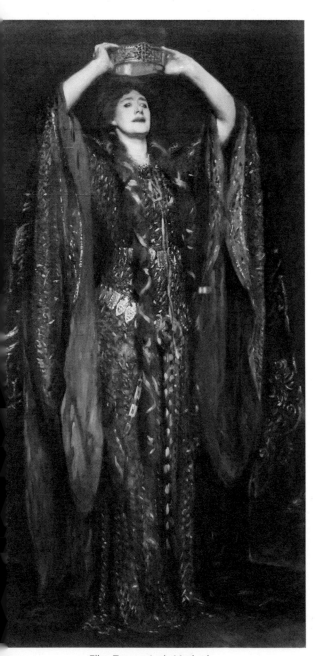

Ellen Terry as Lady Macbeth
John Singer Sargent, 1889

flowers rather than appreciating the sweet scented violets in her hands, in *Choosing* (1864). The marriage only lasted ten months, although the separation was amicable.

Ellen returned gratefully to the stage, but again gave it all up for another man. Not satisfied with her performance opposite Henry Irving in *Katherine and Petruchio*, and finding love again with the architect Edward Godwin, Ellen retired from the stage for six years. The couple couldn't marry due to a lack of divorce from Watts, but they had a daughter and a son, using the surname 'Craig' to disguise the illegitimacy.

When her relationship with Godwin failed, Ellen joined forces with Henry Irving, famous for his Shakespearean roles. As a team they toured Britain and America, and Ellen also managed her own theatre company back in London. Irving was separated from his wife and Ellen was single, so the couple were lovers as well as the most famous acting duo of their generation. Her most famous role was probably that of Lady Macbeth, with a costume especially designed for her made from over one thousand beetle-

wings sewn onto fabric, shown in the most famous portrait of her (1889) by John Singer Sargent.

Ellen Terry used her fame to endorse many products, including ginger ale and 'Koko' hair preparation, which she claimed 'stopped the hair from falling off'. She continued on the stage, taking only a brief break in 1905 when Irving died. She married once more to her co-star James Carew in 1907. He was thirty years her junior and in a repeat of

Ellen Terry as Nurse
Unknown, 1915

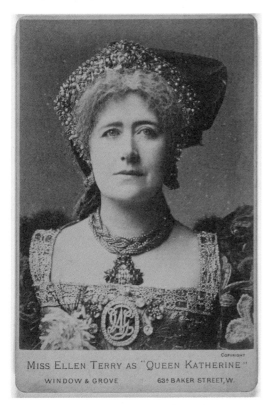

Miss Ellen Terry as Queen Katherine
Window & Grove, 1880s

her marriage to Watts, the age gap proved too great and the marriage was a failure. From 1916, aged nearly seventy years, Ellen began a film career, staring in early moving pictures, whilst also lecturing on Shakespeare in England and North America. She finally retired from stage and screen in 1922. In 1925, she was only the second actress ever to have the title 'Dame' bestowed on her. With failing eyesight and senility, Ellen died, aged eighty-one at Smallhythe Place in Kent, which is now a museum in her memory.

Mary Hillier
1847-1936

When Mr and Mrs Hillier welcomed their fourth child into the world during the cold winter of 1847, little did they know that Mary would become the world-famous face that epitomised a pioneering art medium. At that time, their home in Freshwater, on the south-western side of the Isle of Wight, was quiet, home to respectable manual workers like Mr Hillier, the village shoemaker, but all that would change when Alfred, Lord Tennyson decided to make his home there, bringing with him the leading lights of nineteenth-century art and literature.

Mary's elder sister, Sophia, found work in the Tennyson household as a maid, and Mary was scooped up for a similar role herself when she took a note down to Dimbola Lodge, home of Julia Margaret Cameron. Sophia had recommended Mary for the role to Mrs Cameron, but it wasn't only cleaning that Julia had in mind. She had received her very first camera for her forty-eighth birthday and wanted to take electrifying and startling images. She needed help not only in front of the lens but

also behind. Mary's good looks and practical nature made her ideal for the role. Suddenly Mary was not just the shoemaker's daughter from Freshwater, she was a saint, a heroine and the epitome of gentle beauty.

Mary was known as 'Mary Madonna' in Freshwater because she appeared repeatedly in images as the Virgin Mary, either holding a baby or on her own, her head covered with a cloak, creating a halo. According to a visitor to Dimbola, Julia would draw attention to her maid by instructing her to stand by the window, then exclaiming, 'Isn't

Holy Family
Juia Margaret Cameron, 1872

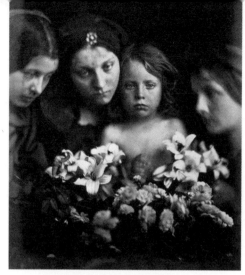

The Return after Three Days
Julia Margaret Cameron, 1865

she perfect in that light, and in profile as you see her now?'

Mary helped not just in front of the camera but she also did a large amount of the practical business of developing the images. This involved her hands being in and out of all sorts of chemicals quickly and carefully so as not to poison herself or ruin the glass plate negative. She would then have to arrange herself and sit for a long time in the pose requested by Julia whilst the plate captured her image, then once again plunge the plate into chemical baths and vanish to capture the picture. From the early 1860s until Julia returned to Ceylon in 1875, this was Mary's life, but after her mistress' departure, she married Thomas Gilbert, the gardener of neighbour George Frederic Watts. The family lived in a little cottage in the grounds of Watts's house, The Briary, just down the road from Dimbola. Suitably, Mary's first two children, her daughter Julia and her son George Frederick, were named after the artists in her life.

When interviewed for local newspapers in her old age, Mary revealed that she didn't enjoy sitting for Julia's photographs but was willing to suffer because Mrs Cameron enjoyed photographing her, which might explain why Mary refused to appear in any photograph, including family ones, after Mrs Cameron had left. Mary lost her eyesight in later life due to cataracts and possibly also the effects of silver nitrate, the photographic solution with which she spent so much of her early life in contact. Two final images of her exist: a painting of her at eighty, by Ida Perrin, and a bas relief by Ida's daughter, as a blind and still beautiful old lady, a celebrity in her corner of the Isle of Wight, well remembered through articles in the *Isle of Wight County Press*. In her obituary, it was recalled how Watts had referred to her image as 'Quite Divine' and how all who knew her loved her. Her husband died in 1928 and Mary died, aged eighty-eight, in 1936, and was buried in All Saint's churchyard, close to the Tennyson family vault. On her headstone is inscribed 'Her children rise up and call her blessed', which seems a fitting epitaph for a maid who will be forever remembered as the 'Madonna' of Freshwater.

Opposite – *The Kiss of Peace*
Julia Margaret Cameron, 1869

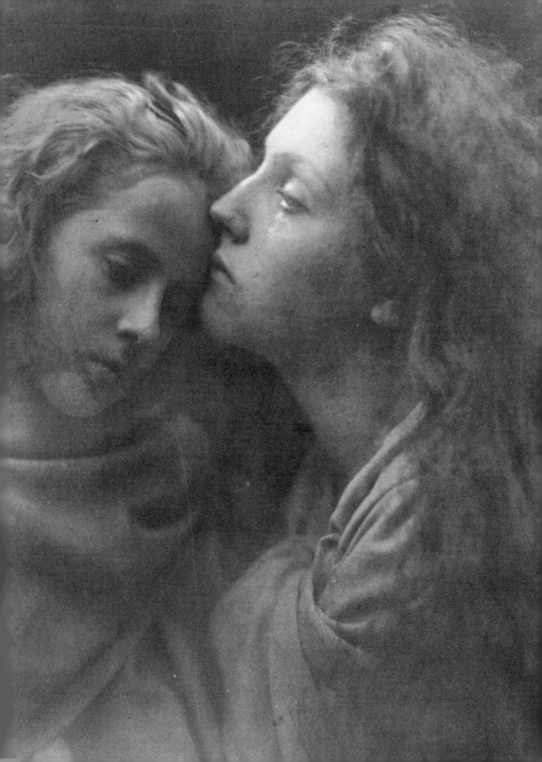

MARY RYAN

1848 - 1914

The first eleven years of Mary Ryan's life gave no hint of the fairy tale that was to follow. Mary and her mother had made their way over from their native Ireland, but a lack of work had left them reduced to begging on Putney Heath in London. It was there that the photographer Julia Margaret Cameron discovered the pair while out walking. Mary's beauty touched Julia's heart so much that she took the child into her own home, whilst also sorting out accommodation and work for Mary's mother. When Julia moved to Freshwater on the Isle of Wight, little Mary Ryan went with her. Mrs Ryan stayed in London, trusting the rich, eccentric woman to raise her daughter, and Julia took the responsibility very seriously indeed.

The playwright Henry Taylor was an old friend of Mr and Mrs Cameron and when he visited in 1861, he found Mary receiving her education alongside the Julia's own sons. Taylor asked 'What will become of her? If she is to be a servant, I am afraid there is no such thing as a good servant who is fond of reading.' Julia's views were somewhat more enlightened and she encouraged Mary in her studies, even if that did leave room for some confusion in her place in the house. Henry Taylor called the girl 'naughty' and blamed her education for making her forget her place, but when the Swedish photographer Oscar Rejlander visited Julia in 1863 to photograph her staff, Mary could be seen performing household duties in a series of images, her cheerful smile never wavering.

Young Man and Woman Leaning on a Picket Fence
Julia Margaret Cameron, 1873-4

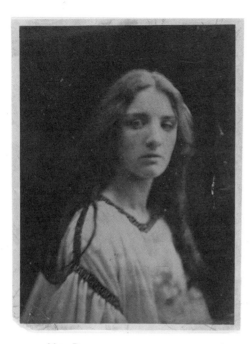

Mary Ryan
Julia Margaret Cameron, 1865-6

Once Julia started taking photographs, she used Mary Ryan in a variety of roles. Mary was 'The May Queen', Juliet and Queen Esther, as well as reminders of her roots as in *My Beggar Maid, Now 15!* and *The Irish Immigrant.* As well as her household duties and now artistic endeavours, Mary also embraced a third role as gallery hostess, as Julia sent her along with her exhibition of photographs to write receipts and give information about the photographs of which she had been a part.

It was during the 1865 exhibition at French's Gallery in London that a young trainee civil servant called Henry Cotton fell in love with a beautiful girl in a photograph. The picture was *Cordelia Kneeling at the Feet of King Lear*, and imagine his surprise when he went to pay for the work only to find the beautiful 'Cordelia' writing out his receipt. He kept the receipt in his breast pocket next to his heart and swore he was going to marry her. Julia, obviously not taking her role of protector to her maids lightly, told him to come back once he had qualified and she'd consider his request. So he did.

The couple were married in 1867 in Freshwater and Alfred, Lord Tennyson, Poet Laureate and neighbour, lent the happy couple his carriage for their wedding. Mr and Mrs Cotton became a respectable colonial family, much like Julia Margaret Cameron's own early married life had been, living in India for seven years before Mary returned with her children to live in England. Henry Cotton became Chief Commissioner in Assam, where he campaigned for fair treatment and reforms for the plantation workers, for which he received a knighthood and Mary, the Irish beggar, became Lady Cotton. When she died in 1914, she had climbed the social ladder and repaid Julia Margaret Cameron's faith in her, whilst using her fairy-tale story to bring justice and kindness to the world.

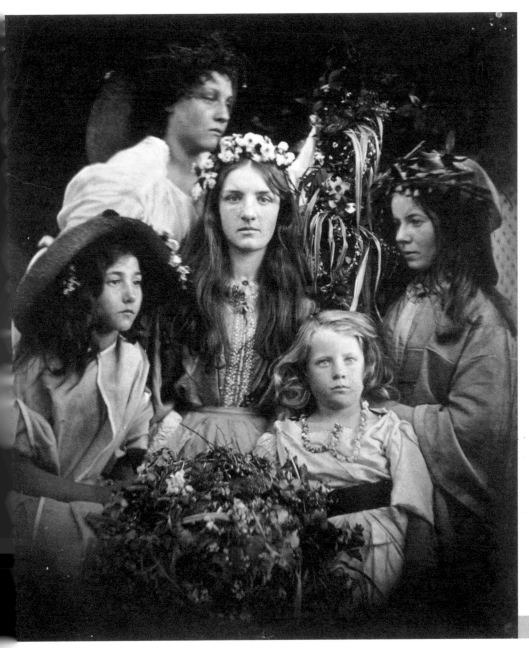

May Day
Julia Margaret Cameron, 1866

Keytumas 'Keomi' Gray

1849-1914

We may never know if it was on purpose or entirely by chance that painter Frederick Sandys happened upon a Romany camp near his native Norwich in 1862. His marriage to wealthy, beautiful Georgina Creed was not very successful, so maybe it was more than a model he was after, but he certainly met his match in Keytumas Gray, better known to her friends as 'Keomi'. She was a forceful and wayward girl, but exuded lush sexuality that fitted the bill for Pre-Raphaelite women of the 1860s. Dante Gabriel Rossetti had stopped producing watercoloured chaste medieval maidens since his meeting with Fanny Cornforth, and Sandys, very much influenced by his bohemian friend was keen to join the trend for hot-blooded, slightly dangerous women.

If the stories about Keomi are to be believed, she was definitely wild. According to gossip, she stoned to death a raven just for the fun of it;

however, as in most biographies of women, juicy gossip was often invented to fit the reputation of the subject. Either way, she inspired not only Sandys but also many of his friends. Sandys took her to London to show her off and Rossetti immediately added her to the bevy of beautiful women in *The Beloved* (1865–6). Her earthy sense of humour, as well as beauty, inspired Rossetti, much in the same way Fanny Cornforth made him laugh as he painted. Keomi inspired the character of 'Kiomi' in George Meredith's novel *Harry Richmond* (1871) and 'Sinfi Lovell' in Theodore Watts-Dunton's novel *Aylwin* (1898). Sandys placed her in the centre of his exotic and glamorous canvases, including *Vivien* (1863), *Cassandra* (1863–4) and most famously as the sorceress *Medea* (1866–8).

Not only did Keomi fill Sandys's canvases, she also filled his home with children. Whilst posing for

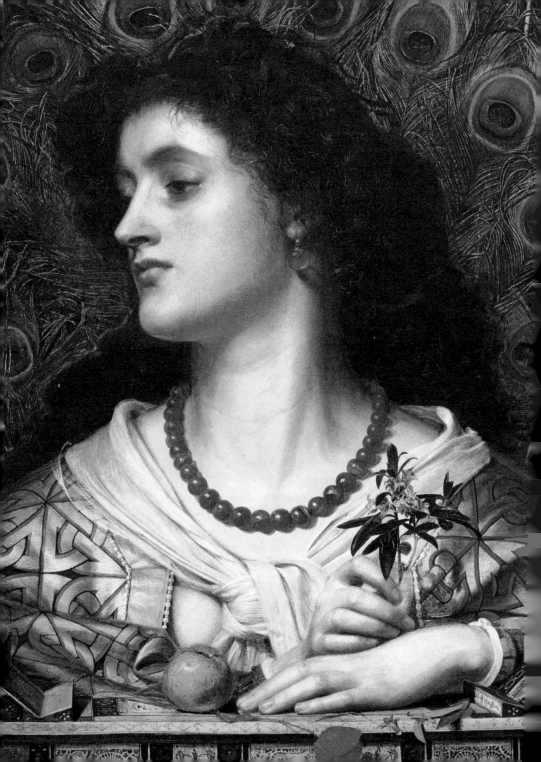

paintings, Keomi had four babies between 1864 and 1868. Sandys was technically still married, but rather drawn-out and unpleasant separation proceedings were ongoing. In the 1864 divorce papers, Georgina claimed that not only was Sandys cruel to her, hitting her in the face with a book, but he also had a mistress. He denied both charges but still kept a household of Keomi and their children.

However, no matter how vivid a presence Keomi was in Sandys's life, she was a traveller at heart and wasn't about to be shut up in a house in London. She took her children home to Norfolk and married horse dealer and fellow Romany, Charles Bonnet, in 1875. Charles and Keomi had three more children and lived back in the heart of the Romany community. At the turn of the century another painter noticed the beauty of Keomi through her daughters. Ellen, or 'Nelly' Gray, daughter of Keomi and Charles, posed for Alfred Munnings, who showed considerable interest

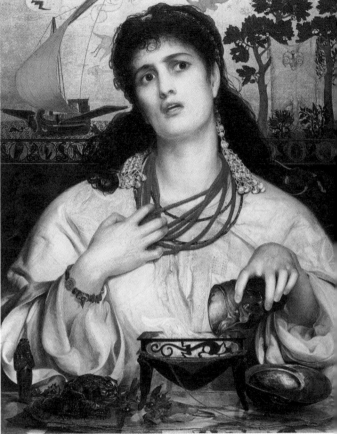

Medea
Frederick Sandys, 1868

in Keomi's stories of bohemian Chelsea almost half a century earlier. Keomi died in 1914 and, despite her unconventional life, is buried in a tastefully traditional grave with her husband, topped by a stone angel.

Opposite – *Vivien*
Frederick Sandys, 1863

Mary Seton Watts
1849-1938

Mary Seton Fraser Tytler's mother died shortly after Mary came into the world. Her father, a civil servant in India, sent sisters Christiana, Etheldred and Mary back to Scotland to live with their grandparents in a castle on the shores of Loch Ness. He returned a decade later with a new wife and children to add to the family. The family had land and connections but no money, so it fell to the children to either make a success of their careers or, in the case of the daughters, marry well. Mary and her sister Christiana had other ideas....

Christiana wanted to be a writer and Mary an artist, and the pair collaborated on illustrated books of poetry, such as Christiana's poetry volume *Sweet Violet* (1868). As part of their entry into society, the girls were not only presented to the Princess of Wales as debutantes but also visited friends in fashionable places, such as Freshwater on the Isle of Wight. Mary, Etheldred, Christiana and younger half-sister Nelly fell into the hands of Julia Margaret Cameron, who photographed them together as *The Rosebud Garden of Girl* (1868). When the American poet Henry Longfellow met them at Freshwater, he declared, 'It was worthwhile coming to England to see such young ladies!'

This connection to Julia Margaret Cameron and her family was probably the reason that Mary visited Little Holland House in 1870 and there met George Frederic Watts. Despite being a somewhat reclusive divorcee and over thirty years her senior, she fell in love with him, although it took the couple another sixteen years to actually make it to the altar. In the meantime, Mary trained at the newly established Slade School of Art, which offered training and education to both male and female students on the same terms, where she was taught by Edward Poynter. She rented a studio and worked with modest success as a painter, whilst also teaching clay modelling to children in deprived areas in London. Whilst remaining close friends and in regular correspondence all through the 1870s and 1880s, it was in the winter of 1886 that Mary finally married Watts in the company of their friends, May Prinsep and her husband.

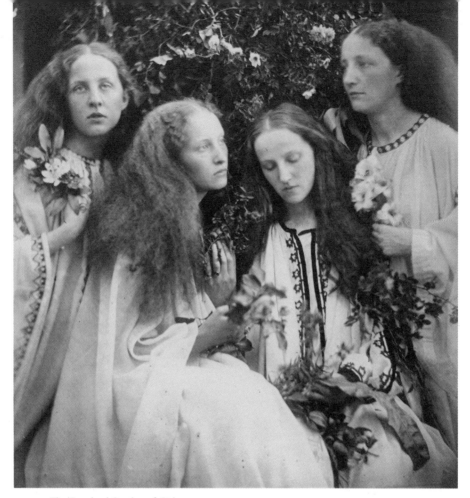

The Rosebud Garden of Girls
Julia Margaret Cameron, 1868

George and Mary Watts moved to Surrey for his health, settling in a neighbouring house, Limnerslease, to May and her husband, in Compton. The house and its studio provided a creative centre for both of them, sometimes collaborating on projects and paintings. The greatest of these was the Watts Mortuary Chapel, a glorious red, Art Nouveau building in the centre of a graveyard close to their house. In the building and decorating of it, Mary trained local people to create fantastic beasts and figures that adorn the structure, together with the breathtaking interior of angels and heavenly figures that cover the walls. As an extension of her previous work of bringing art skills to the masses as part of the

Home Art and Industries Association, Mary formed the Compton Potters' Arts Guild to continue the work and training of the local people, including returning soldiers from World War I as a form of occupational therapy as well as industry.

Mary remained devoted to Watts for the rest of his life, including writing a two-volume biography of his life and career, published in 1910. When George died in 1904, Mary set about creating the perfect gallery as his memorial. The building had begun the year before on Watts's eighty-sixth birthday, and paused while the collection toured in the year after his death, but Mary added a sculpture gallery and further galleries in order to display her husband's work to their fullest. When it opened, over one hundred paintings were shown to the public who could also buy a catalogue. It closed again in 1914, when Mary, a committed suffragist, feared an attack from suffragettes who had targeted art for vandalism. However, the gallery has survived changes in taste and structural challenges to remain a tribute to both husband and wife today. Mary died, aged eighty-eight, in 1938 and was laid to rest next to her husband, in a casket she had made herself at the potteries she had founded.

The interior and exterior of Watts Mortuary Chapel
Mary Watts, 1896-8

ALICE LIDDELL

In a quiet south coast town in 1934, an old lady died and as per her request her ashes were buried near the war memorial that held the names of two of her three sons. It was only when her headstone was erected that her secret was revealed. Seventy-two years earlier she had been a little girl called Alice who, one warm afternoon on a riverbank in Oxford, had begged Mr Lewis Carroll for a story....

Daughters of the Dean of Christ Church, Oxford, Alice and her sisters, Lorina and Edith, had been friends with a shy, awkward young man by the name of Charles Lutwidge Dodgson, better known today by his pen name Lewis Carroll. He, in turn, loved to tell stories to them filled with fantastic places and nonsense. Carroll's fascination with his young friends became part of his photography too, turning the well-to-do young daughters of Oxford social elite into beggar-girls and princesses, as well as taking portraits of them sitting on vast silky cushions, like self-satisfied kittens.

Much has been written about our modern discomfort over the relationship between Carroll and Alice Liddell, not to mention many of the other young girls he photographed in ways that would not be acceptable today. There are also questions over Carroll's relationship with Lorina, Alice's older sister, who was much nearer to Carroll in age. Mrs Liddell was nick-named the 'King-Fisher' because of her obsession for getting her daughters married to rich and powerful men. Carroll was neither, and he

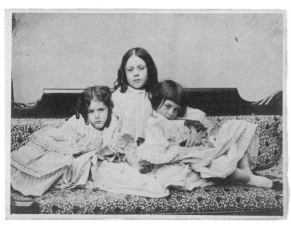

Edith, Ina and Alice Liddell on a Sofa
Lewis Carroll, 1858

was sent packing after the suspicions over the nature of his relationship with the girls was revealed.

Alice become a young woman of marriageable age and probably in an attempt to remove her further from Carroll, the Liddells rented a cottage in fashionable Freshwater on the Isle of Wight, not too far from Julia Margaret Cameron's home, Dimbola Lodge. The Liddell girls were once more required to pose for the camera. Although she took photographs of all three girls posing together, Julia, like Carroll, singled out Alice as her model for special treatment, picturing her as Pomona, Alethea, Ceres and St Agnes, proud heroines with Alice's own defiant expression.

The Liddell girls were taken on a grand tour to show them off to titled and important men in the hope that Mrs Liddell would get the sort of son-in-law she dearly wanted. It is rumoured that Queen Victoria's youngest son, Prince Leopold, paid court to either Alice or Edith, but although Mrs Liddell must have been thrilled it is unlikely the royal family would have been so delighted. The relationship he had with the Liddell girls was dear to the prince; years later Leopold called his first daughter 'Alice', which 'Alice' scholars maintain is in reference to Miss Liddell. As it unhappily transpired, Mrs Liddell would indeed see one of her daughters walk down the aisle with a prince. Shortly before her marriage in 1876, Edith died suddenly, traumatising the family. Prince Leopold acted as pall bearer at her funeral.

Alice herself married a famous cricketer, Reginald Hargreaves, in 1880 and hid behind his name and fame for the rest of her life. Although it is commonly believed that the Liddells cut all ties with Lewis Carroll, he acted as godfather to one of Alice's sons and remained

Alethea
Julia Margaret Cameron, 1872

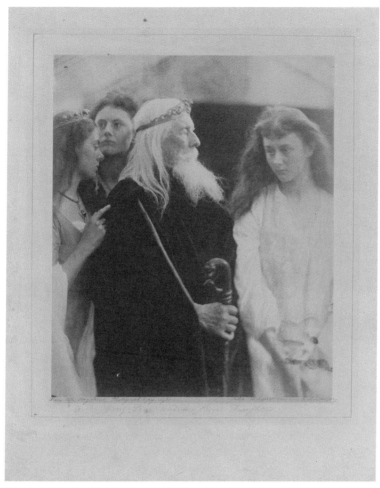

King Lear Alotting His Kingdom to His Three Daughters
Julia Margaret Cameron, 1872

in contact with the remaining two sisters. It was only when the death of her husband in 1920s left her short of money did Alice reveal who she was by selling the original manuscript of *Alice's Adventures Under Ground* (the original title of *Alice's Adventures in Wonderland*) that had been given to her by Carroll. The manuscript sold for over £15,000. Despite hiding from her namesake for most of her adult life, Alice had Lewis Carroll's 'Alice' to thank for a comfortable old age.

LILLIE LANGTRY
1853–1929

Born on the beautiful island of Jersey in the English Channel, Emilie Charlotte Le Breton, or 'Lillie' as she was known, always dreamt of living in London. The daughter of philandering vicar, the Very Rev. (but not very faithful to his wife) William Corbet Le Breton, and the only girl in a large family, Lillie proved so wilful and intelligent that her family's only option was to tutor her with her brothers. As a result, Lillie received a much wider education than was usual for girls at that time, almost foreshadowing how she would never be satisfied with only experiencing the narrow slice of life reserved for women of the age.

Lillie's ticket off the island came in the shape of Irish landowner, Edward Langtry, whom she married in 1874. He was a wealthy yacht owner and Lillie insisted he used his massive boat to get her off the island on her way to the good life in Belgravia and Park Lane in London. Lillie soon fell into the company of artists, starting with portraitist and Jack the Ripper suspect Frank Miles, and moving on to fellow former Jersey resident John Everett

Millais. When Millais met Lillie, she had been in mourning for her younger brother, Reginald, who had died in a riding accident aged twenty-one. She had been wearing a simple black dress and no jewellery, which became her trademark long before Coco Chanel made the little black dress a chic statement. Millais' 1878 portrait of her, entitled *A Jersey Lily*, pictured her holding a lily, the symbol of Jersey, as well as it being a play on her name, even though the flower she's actually holding is a Guernsey Lily, but Millais was banking on the London art elite not knowing the difference. During the sittings, Millais and Lily spoke Jèrriais to each other, the language of Jersey, and the beauty of her portrait made her much in demand from other painters. Edward Poynter also painted her portrait in 1878, and Edward Burne-Jones reportedly used her as the goddess Fortuna turning the giant wheel of mankind in *The Wheel of Fortune* (1871–85).

As Lillie's fame grew, so did her list of admirers. In 1877, the Prince of Wales arranged for Lillie to be seated next to him at a dinner party and she

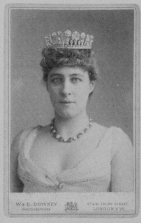

Mrs. Langtry
W.&D. Langtry, 1892

soon became one of his many mistresses, although Lillie herself was also conducting an affair with a man whose child she had in 1881. It was Lillie's other affair in 1879 with the Earl of Shrewsbury that finally pushed Mr Langtry towards divorce, and he threatened to cite the Prince of Wales, amongst others, as co-respondents. Worried about his reputation, the Prince withdrew from the affair but the couple remained friends for the rest of their lives. Apparently not overly worried about her reputation, Lillie embarked on another royal affair, this time with the Prince of Wales's nephew, Prince Louis of Battenberg, with whom she allegedly had a daughter, Jeanne Marie.

All this philandering cost money and by 1881 Lillie needed a source of income. On the advice of her friend Oscar Wilde, Lillie took her looks and wit on to the stage. After training, she debuted at the Haymarket Theatre in *She Stoops to Conquer*. With her former lover, the Prince of Wales, in the audience, people were drawn to see what the fuss was about and Lillie became a sensation. Her fame was such that she was approached to advertise cosmetics, becoming the first woman to endorse a product when she became the face of Pears soap in 1890. The following year she was encouraged to take her show on the road, all the way across the ocean to New York where she was welcomed off the ship by Wilde who was on a lecture tour. The show made enough money for Lillie to refurbish and manage her own theatre back in London, and for her to dabble extensively in her new passion for racehorses, after a bit of a passion for rich American horse breeder Frederick Gebhard and then the extremely rich Scottish horse breeder George Alexander Baird.

In 1888, Lillie bought a ranch in California, growing grapes for wine, and even though she sold it in 1906, Langtry Farms still operates as a vineyard today. Her travels in America had inspired her to become an American citizen and the first thing she did on acquiring citizenship was divorce her husband and marry Hugo Gerald de Bathe, who was both young and wealthy, a winning combination. On de Bathe's father's death, Hugo inherited the title of Baronet, and Lillie lived out the rest of her life in Monaco as Lady de Bathe. The couple lived in separate countries, and only saw each other at social gatherings. Lillie died in 1929 and was taken back to Jersey to be buried.

Opposite – *Lillie Langtry*
George Frank Miles, 1884

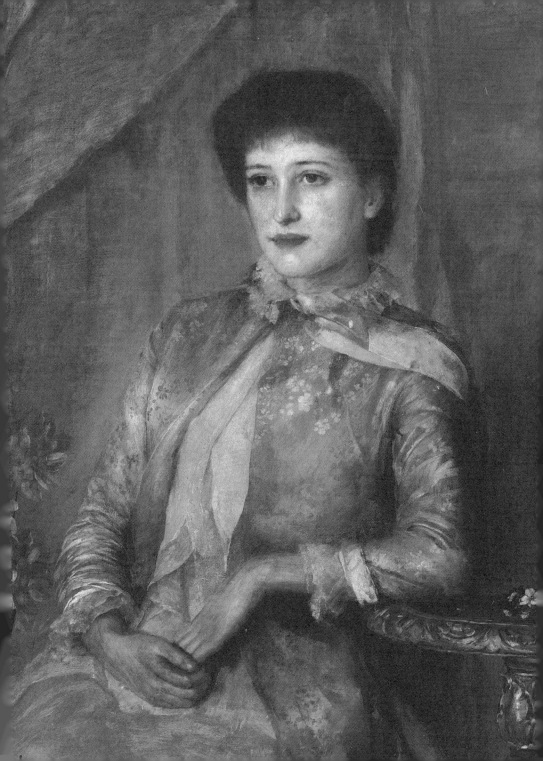

May Prinsep
1853-1931

May, born Mary Emily Prinsep, was the daughter of Charles Prinsep, standing counsel to the East India Company and Judge Advocate General of India. Born in Calcutta in 1853, she was one of eight children, six of whom survived infanthood, and after her mother's death and father's decline in health, the Prinsep children returned to England. When her father died in 1864, May and her siblings were sent to live with their various relations, and May found herself in the centre of the bohemian artistic elite at Little Holland House in London.

Becoming a member of the Little Holland household enabled May to mix with artists and writers, including George Frederic Watts who lived there with May's uncle, Henry Thoby Prinsep, and Aunt Sara. Her nickname was 'the vision of beauty', and she posed for both her cousin Val Prinsep and for Watts. Aunt Sara was also the sister of Julia Margaret Cameron and so it was not long before May found herself in front of her Aunt Julia's lens. Spending several of her summers on the Isle of Wight, May quickly

became part of Cameron's artistic vision, appearing in scores of her pictures for the next ten years.

It was whilst on the Isle of Wight that May met her first husband, stockbroker Andrew Kinsman Hichens. He was also brought in to pose for Julia in a suitably romantic fashion for a photograph entitled *Gareth and Lynette*. This was her aunt's way of heralding their

Gareth and Lynette
Julia Margaret Cameron, 1874

nuptials, and May and Andrew were married at All Saint's Church in Freshwater on 10 November 1874, attended by family and close friends such as the Tennyson family.

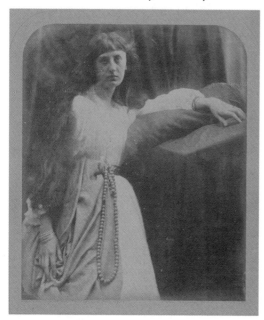

Pre-Raphaelite Study
Julia Margaret Cameron, 1870

May's family moved with Watts to a new house next to Lord Leighton's house in Kensington and it was there that May met and posed for Leighton in 1885. Andrew and May lived in London, but also had a house named Monkshatch in Compton, a small village outside Guildford in Surrey. When Watts's health failed, he spent winters in the sun-warmed rooms of Monkshatch with his second wife, Mary Seton Watts. Watts and Mary loved the house and village so much that they built their own home next door, called Limnerslease. Watts died in 1904, shortly followed by Andrew, leaving May a widow at the age of fifty-three.

Two years later, May's brother paid a visit from Australia. After being separated from his family back in England, he had become close friends with Hallam Tennyson, son of the Poet Laureate, who had become Governor General of Australia. Alfred, Lord Tennyson died in 1892 and Hallam, now Second Baron Tennyson returned to England with his wife and three sons. Two of his sons died in World War I, and the grief also claimed his wife, leaving Hallam a widower in 1916. Old friends May and Hallam grew closer and married in a quiet ceremony in 1918. As Lady May Tennyson, she kept Monkshatch in Surrey but also lived on the Isle of Wight at the Tennyson family home, Farringford. She became a benefactor for local causes, helping to set up a cottage hospital, something dear to Julia Margaret Cameron's heart during her time in Freshwater. In 1925, May donated £800 to purchase the Tennyson Memorial Ambulance, manned by volunteers. When she died in 1931, her ashes were taken back to Compton to share a resting place with Andrew, Mary and George Frederic Watts in sight of Limnerslease.

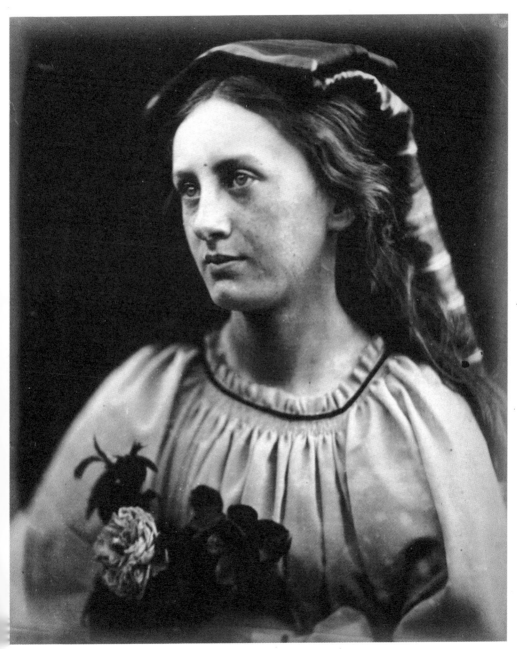

La Contadina
Julia Margaret Cameron, 1866

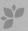

Rosa Corder

1853-1893

Few women have such a contrary reputation as Rosa Corder. In her lifetime, she was primarily known for her talent but posthumously became more famous for being the criminal cat's-paw of a thoroughly despicable character who also happened to be her lover.

Rosa was the daughter of merchant and musician, Micah Corder, who sent both her and her brother, Frederick, to music lessons from an early age. Frederick went on to become a respected composer but Rosa also took training in painting and portraiture from Frederick Sandys, and excelled as a draughtsman and copyist. She made friends with Ellen Terry, who described her as 'one of those plain-beautiful women who are far more attractive than some of the pretty ones', and W. Graham Robertson described her as 'gentle and crushed looking'. While still in her teens, Rosa was introduced to the art elite whom she impressed with her talent and intelligence not only as a painter but also as a linguist, producing a translation of *Science without God* by Rev. Father Didon before she was twenty.

Dante Gabriel Rossetti saw her work and considered employing her as an assistant, and through him Rosa met art dealer and nefarious jack-of-all-trades, Charles Augustus Howell. Howell acted as Rossetti's business assistant and had facilitated the retrieval of his manuscript from Elizabeth Siddal's coffin. A man with a colourful reputation and a tendency to embellish the truth, he seemed to have recognised in the young woman an ability to produce passable copies of his employer's work. According to rumour and modern research, during the 1870s Howell and Rosa operated a studio of forgeries, which Howell then sold on as the real thing. In his book of Victorian celebrity caricatures, published in 1922, Max

Beerbohm showed Rosa turning out Rossetti 'stunners' while Howell keeps his ear to the door. In fact, Howell and Rosa had become lovers as well as business partners, with the much older, married Howell making use of twenty-year-old Rosa's talents. As the business of making legal copies of popular art works to sell was not uncommon in that period, it possibly should be questioned whether Rosa was fully aware of the role she was playing in Howell's forgery business.

In the meantime, Rosa built her reputation in a specialised field. She had a studio in London but took over the studio of equine artist Harry Hall in Newmarket. In 1883, Rosa became well known and respected as a portraitist of turf

Rosetti and his Circle
Max Beerbohm, 1922

celebrities, both horse and human, including a painting of famous jockey, Fred Archer. Sporting newspapers respected her understanding and love of horses, and she even appeared in court testifying against instances of cruelty to animals. She posed for James Abbott McNeil Whistler in one of his favourite and best known paintings, *Arrangement in Black and Brown* (1876–8) for which Whistler would make her pose against a dark doorway for hours at a time until she fainted.

Rosa's confidence and ability led posthumous biographers to label her promiscuous and fully conscious of her criminal activities, but between the ages of twenty and thirty she was operating as an artist in a male-dominated field, especially in terms of her sport art, alone. As she was gaining respect with the horse-racing community, she was conversely giving birth in secret to Howell's daughter, Beatrice Ellen Howell, in 1883. She and Howell continued their relationship after the death of Howell's wife Kitty, until Howell's

death in 1890. It was rumoured that he had been found with his throat cut in a gutter, a sovereign between his teeth, but the truth was far less exotic. He caught a chill and was confined to hospital where Rosa visited him daily until he died and she then took over care of his daughter, Rosalind, who grew up with Beatrice. Rosa died only three years later, after catching cold after horse riding. It was reported that she took extra care to make sure the horses were dried and stabled before her own needs, and this caused pneumonia, which claimed her life in 1893, aged only forty years.

187

Opposite – *Arrangement in Brown and Black, Portrait of Miss Rosa Corder*
James McNeill Whistler, 1878

EVELYN
DE MORGAN

On her seventeenth birthday, Evelyn de Morgan wrote in her diary, 'Art is eternal but life is short.' She should have known because by that age Evelyn was already an accomplished artist, having started drawing lessons at the age of fifteen. Born Mary Evelyn Pickering, her uncle John Roddam Spencer Stanhope was an artist who encouraged her and gave her lessons in addition to the scholarship she had won to the prestigious Slade School of Art. However, the scholarship meant she had to draw nudes in charcoal, a technique she hated. She eventually declined the offer, preferring the tutelage of her uncle in his Florence home, which enabled her to broaden her education of Renaissance art at the same time, especially Botticelli, whose art was a great influence upon her. The same year as she started visiting Italy, she sold her

The Angel with the Serpent
Evelyn de Morgan, c.1870-75

Queen Eleanor and Fair Rosamund
Evelyn de Morgan, 1905

first painting, *Tobias and the Angel*, and the following year, 1876, saw her exhibit her work *Catherine of Alexandria* in the prestigious Dudley Gallery in London.

Despite specialising in classic, ambitious paintings of goddesses and fantasy scenes, her favourite model was her younger sister's nanny, Jane Hales, who appeared in many of Evelyn's paintings, including arguably her masterpiece *Aurora Triumphans* (1877–8). Evelyn worked in a Pre-Raphaelite style, influenced by Edward Burne-Jones's leanings towards Symbolism rather than the original Pre-Raphaelite Brotherhood adherence to painting from nature. She often showed strong female figures overcoming obstacles as they pursued spiritual happiness. In 1889, Evelyn signed the Declaration in Favour of Women's Suffrage, and like many other female artists, boycotted the Royal Academy in favour of more progressive galleries such as the Grosvenor Gallery and the Dudley Gallery. She also expressed her pacifism in her art against the wars during her lifetime, including the Boer War and World War I, showing figures appealing against the dark tide of violence that threatens to engulf them.

She met her husband, William de Morgan (1839–1917), at a fancy dress ball where she was dressed as a tube of paint. He made ceramics, vases and large, beautifully decorated plates, and Evelyn used money she

Night and Sleep
Evelyn de Morgan, c.1870-5

made from the sale of her paintings to support his business and to contribute ideas to the decoration of his ceramics. In her famous 1909 portrait of her husband, Evelyn showed William holding a vase that shimmers with the special iridescent glaze for which he was famous.

For one of her later pieces, Evelyn used Jane Morris as a model for a woman anguished at time passing, in *The Hour Glass* (1905). By this time, Jane was in her sixties but still a formidable presence physically, yet the effects of ageing on a woman's looks was a striking issue and using a former 'super-model' as the figure made a very modern point about the issue.

William de Morgan died in 1917, followed by Evelyn two years later. Despite Evelyn's refusal of the Royal Academy, the couple were described by its president Sir Edward Poynter as 'two of the rarest spirits of the Age.'

The Hour Glass
Evelyn de Morgan, 1905

Overleaf – *Aurora Triumphans*
Evelyn de Morgan, 1877-8

Kate Bunce

1856-1927

According to *Aris's Birmingham Gazette*, of which John Thackray Bunce was the editor, his daughter Kate Bunce owed her artistic talent to him. It's true that Bunce had a great interest in art in his home city of Birmingham, being both patron of the new museum and art gallery and supporter of the city's art school which his two daughters, Kate and her older sister Myra (1854–1918) would attend. Out of the five Bunce children, only Myra and Kate would live into adulthood, but together they would create some of the most intriguing and arresting images of women of their era.

As a prize-winning student at the Birmingham School of Art, great things were expected of Kate, but she was in no hurry to expand her horizons. Even though she lived with Myra in Edgbaston for the whole of her life, her art was shown all over England in major exhibitions. Kate might have been at the art school when William Morris and Birmingham-born Edward Burne-Jones visited to encourage and inspire the generation of artists of which the Bunce girls were part. Typically, Kate's work involved tall, languid medieval women in strongly coloured surroundings and

The Chance Meeting
Kate Bunce, n.d.

Melody
Kate Bunce, c.1895-7

clothes, framed in striking metalwork by Myra, the most famous of which is *Melody* (1895–7). Not only does the dark-haired musician wear a delicate ring and necklace but behind her is an ornate mirror, all pieces that show an appreciation of her sister's art medium. Myra is also believed to have been the lovely musician pictured. The poetry as well as the art of Dante Gabriel Rossetti proved to be a major muse for Kate, for

example in her piece *The Keepsake* (1898–1901) which is inspired by Rossetti's poem 'The Staff and Scrip' (begun 1849).

Kate was a member of the Birmingham Society of Artists, exhibiting with them for the first time when she was sixteen, and a founder member of the Society of Painters in Tempera at the turn of the twentieth century. However, as fashion in art moved away from medieval maidens, Kate and Myra concentrated on their work in churches. Swapping beautiful women for saints, they produced large-scale murals and decorative pieces in England, and at the time of her death Kate was working on a painting of St Alban for a cathedral in Saskatchewan, Canada. She also created a war memorial diptych for Stratford-upon-Avon. Her personal life remained extremely private, living for much of her adult life with her sister and then after Myra's death in 1919, on her own. She left *The Keepsake* to Birmingham Museums and Art Gallery, a place so beloved by her family, where it hangs today together with *Melody*.

Opposite – *The Keepsake*
Kate Bunce, 1898-1901

VIOLET MANNERS
DUCHESS OF RUTLAND
1856–1937

When Violet was five years old, her father noticed that she had a talent for drawing. He immediately sought the advice of close family friend, Edward Burne-Jones, as to which school or tutor to send Violet.

Burne-Jones disagreed strongly with any formal training, stating that all she needed was to be placed in front of a mirror and draw herself until she got it right. As odd as the advice seems, Violet grew into an accomplished artist. As part of a wealthy, aristocratic family, Violet was allowed endless time to practise her art and she travelled in Italy and began exhibiting her drawings before she was twenty years old.

Violet married Henry Manners, heir to the Duke of Rutland, when she was twenty-six. Her circle of friends included other heiresses, politicians and members of the social elite. They were known in society as 'The Souls', because someone commented that the circle sat around examining their souls, due to their propensity for intellectual conversation. The women were given equal status to the men within the group and they were free to talk about art and literature, as well as fashion and politics. There

Self Portrait
Violet Manners, 1891

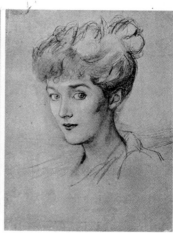

Cecil Rhodes
Violet Manners, 1898

The Countess of Westmoreland
Violet Manners, 1891

Amalia Küssner Coudert
Violet Manners, 1899

was also romance between members. Despite being married, Violet had an affair with fellow Soul, Harry Cust, who was rumoured to be the father of her daughter, Diana.

After the death of her eldest son, Robert, aged nine, Violet learnt sculpture in order to produce a piece for her son's tomb. Her silverpoint pencil portraits of her friends brought her fame and respect as an artist. Her self-portrait was described as the epitome of a 'Burne-Jones woman', with delicate features and wild hair. High-class gossip magazines and newspapers found her fascinating due to her beauty, wealth and talent, and for a while she was seen as the queen of society. It was thought that the children of the Souls, equally as talented and

beautiful, would lead society into the twentieth century with their love of Pre-Raphaelite art.

Sadly, World War I took a huge toll on the Souls. Diana Manners married Duff Cooper after all the sons of her mother's friends who had courted her had died in the trenches. Violet, desperate to save her son, John, from a similar fate, used her power and influence to rig his medical examinations and keep him from the front lines. John never forgave his mother for denying him the chance to fight and spent the rest of his life ashamed and in hiding at Haddon Hall, one of the family homes.

Violet supported a hospital during the war, selling portraits to patrons in order to raise funds. Violet

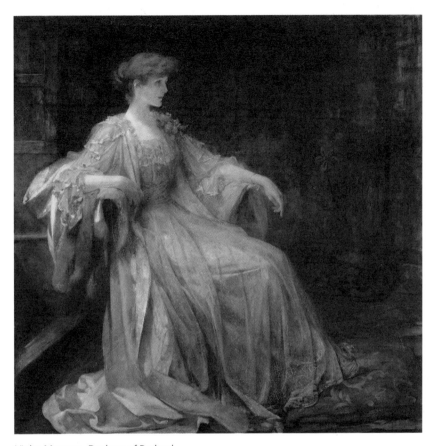

Violet Manners, Duchess of Rutland
James Jebusa Shannon, c.1890

patronised many charities both with her position and her art, and continued to exhibit at the Royal Academy and all over Britain, as well as in France and America. Unusually for a woman at that time, she was equally well known in the newspaper for her driving offences including speeding, failing to obey traffic signals and parking wherever she wanted, for which she remained unrepentant and unapologetic. She died after an operation for appendicitis, aged eighty.

DOROTHY DENE

Born Ada Alice Pullan, daughter of an engineer from Yorkshire, there was little in her background that would hint of the fame that was to come. In one of the many newspaper accounts of her life, it was reported that little Ada would get up in the middle of the night and practise scenes from plays in front of a mirror. One of ten children, including four daughters, Ada's world was turned upside down in 1877. Youngest brother Samuel was born, leaving Ada's mother crippled. The same year, her youngest sister, Dorothy, died, aged only eight

and their father abandoned the family. Mrs Pullan lived as an invalid for only a few more years. Eldest brother Thomas became an engineer, as his father had been before him, but Ada led her sisters Edith, Helena ('Lena') and Henrietta ('Hetty') into modelling. The sisters were tall and beautiful with long, golden-chestnut hair and large violet eyes. Soon they were much in demand in the Kensington area, home to many artists. Ada was posing for artist Louisa Starr Canziani when Frederic, Lord Leighton saw her leaving his neighbour's house and fell in love with her. He had been searching throughout Europe for a model for his painting *Cymon and Iphigenia* (1884) and there she was, literally on his doorstep.

Ada had ambition beyond being an artist's model, even though it had brought her into contact with people such as John Everett Millais and George Frederic Watts. With Leighton as both her employer and patron, she had the chance to follow her dream to become an actress. He suggested she change her name and she took

Dorothy Dene
Ogden's Guinea Gold Cigarette Cards, c.1900

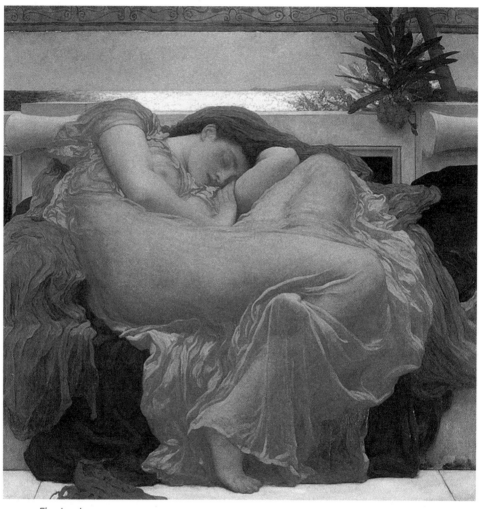

Flaming June
Frederic Leighton, 1878

'Dorothy', in memory of her younger sister. Leighton added 'Dene' and the transformation was complete. Together with Hetty and Lena, the 'Dene' sisters took to the stage and became a sensation. Leighton paid for elocution lessons and further education to help her with her ambition to become a great actress, leading to rumours that, like Jane Morris, Dorothy Dene was the basis for the character of Eliza Doolittle in *Pygmalion*.

Somehow, Dorothy balanced a full career on stage, in both classical and contemporary roles, with becoming the face of Lord Leighton's celebrated art. A lifelong bachelor with tendencies to bi-sexuality, Dorothy was often referred to as 'my wife' by Leighton in private correspondence. Dorothy and her sisters lived in a lavish apartment in Kensington, with Hetty and Dorothy touring with plays both at home and abroad, starring in productions in America and the colonies. Dorothy took her acting very seriously; when starring as the mentally ill character Pauline in *Called Back*, she spent time in Bethlehem Hospital studying the patients to improve her performance.

In 1891, Dorothy went to court against her dressmaker because she refused to pay for dresses that did not fit. In order to prove her point, Dorothy put on the dresses and made the judge examine her, and won the case. She was well known for her wit, intelligence and charm, acting as Leighton's hostess at social events until his death in 1896. Much like Alexa Wilding, Dorothy did not outlive her mentor by many years, dying of peritonitis three years later, aged thirty-nine, two days before the turn of the century.

Crenaia, the Nymph of the Dargle
Frederic Leighton, 1880

Cymon and Iphigenia
Frederic Leighton, 1884

May Morris

1862-1938

Mary 'May' Morris was born on the Feast of the Annunciation, 25 March, in 1862. Her older sister, Jane, was always known as 'Jenny' to save confusion with their mother, the Pre-Raphaelite muse, Jane Morris (née Burden). May popped into the world just a month after Elizabeth Siddal and her unborn baby left it, so you have to wonder how much that affected her parent's relationship with the grieving Rossetti. Certainly, for the rest of his life Rossetti seems to have held a special place in his affections for little May.

May and Jenny began modelling for Rossetti as children. As part and parcel of his obsession with their mother, Rossetti often used May as a handmaiden or an accompanying cherub to Alexa Wilding in paintings such as *La Bella Mano* (1875) or *La Ghirlandata* (1873). May's relationship with Rossetti grew stronger when he stayed with Jane, Jenny and May in Kelmscott Manor in 1871 while

William Morris toured Iceland. It has been suggested that Jane ended her relationship with Rossetti as she worried about the nature of the love between the painter and her daughter, but more likely Rossetti's erratic behaviour and drug-use was too complex for a child to be expected to cope with.

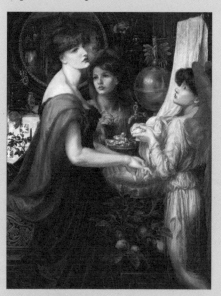

La Bella Mano
Dante Gabriel Rossetti, 1875

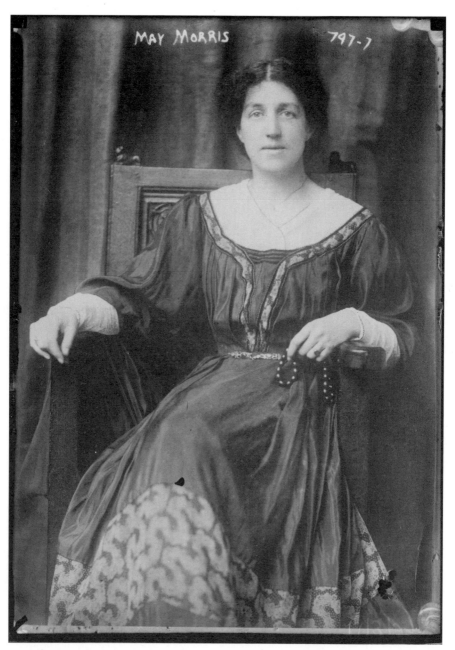

May Morris, seated
Bain News Service, publisher, 1909

In the same year that Jane ended her relationship with Rossetti, Jenny had a boating accident and developed epilepsy. In one year May had lost Rossetti from her life and her sister would never be the same again. It had a terrible effect on the family, causing Jane much stress and illness, and causing William depression. May herself worried that she, too, would suffer from the same affliction that had claimed her sister, as there were traces of it in some of William's more extreme behaviour, and the spectre of the illness put potential suitors off the beautiful and fiercely intellectual May.

To combat the melancholy, May applied herself to needlework. She had been taught to embroider by her mother and aunt, who had both been taught by Morris. In 1885, aged only twenty-three, May became the director of the embroidery department at her father's company Morris & Co. There is no doubt that William was a massive influence on his daughter, who idolised him. May followed her father into politics, joining the Social Democratic Federation in Hammersmith, and in 1884 father and daughter broke from the Federation to form the Socialist League.

Through her political work, May met George Bernard Shaw, Irish writer, vegetarian and all-round bag of contradictions. He declared a 'mystic betrothal' with the twenty-three-year old May, who fell in love with him, awaiting his proposal, which was not forthcoming. May was heartbroken and, in a rebellious move, married a fellow Socialist, Henry Halliday Sparling. He was poor and, according to W.B. Yeats's sister Lily, who worked as an embroiderer for Morris & Co., he was 'the queerest looking young man, very tall, thin, stooped ... no chin and very large spectacles'.

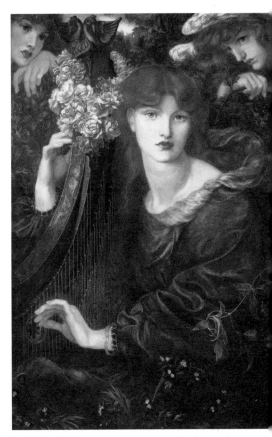

La Ghirlandata
Dante Gabriel Rossetti, 1872

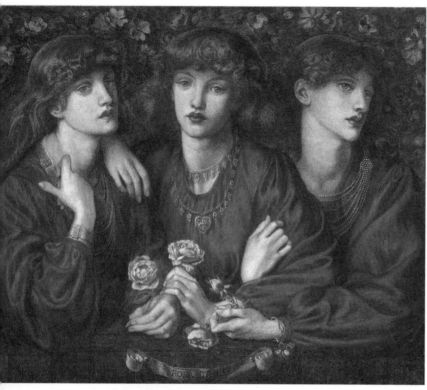

A Triple Portrait of May Morris
Dante Gabriel Rossetti, 1874

The marriage was not a success, and was not helped by the fact that George Bernard Shaw moved in with them and allegedly had an affair with May, which all but ended the matter. May moved home but waited for her father to die before divorcing Mr Sparling, convinced that Shaw was going to finally propose. Instead, he married Charlotte Payne-Townshend, a rich Irish lady who was besotted with him.

Possibly the death of her father,

despite being a terrible blow, together with the divorce from both her husband and her 'mystic betrothal', set May free. She left Morris & Co. and became a freelance designer, embroiderer and teacher, writing articles on historical embroidery and acting as an adviser for colleges setting up embroidery courses. She went on a lecture tour of America, had an affair with lawyer and art collector John Quinn, and generally took every opportunity to

see a bit of life outside Kelmscott Manor as often as she could. She worked tirelessly, editing her father's writings for publication, a mammoth undertaking of twenty-four volumes, published in 1915, the year after Jane Morris's death. Free of her father, mother and lovers, alone with her invalid sister, life must have seemed very quiet for May until the arrival of Miss Mary Francis Vivian Lobb, steam-roller driving, hard-drinking, land-girl inventor.

Miss Lobb had been employed as a land-girl at the farm next door to Kelmscott Manor and had been fired for either drunkenness or swearing, or the first followed by the second. For some reason best known to herself, May employed her straight away and the two became inseparable. Miss Lobb was practical and straight-talking. She scared the hell out of George Bernard Shaw who came round to see his old girlfriend and found a sturdy Cornish woman barring his way. Miss Lobb travelled with May, went camping with her in Wales and toured through Iceland in the footsteps of William Morris. Finally, May's life was filled with laughter, fresh air and a level of companionship she had never received from the men in her life. When May died in 1938, she left everything to Miss Lobb. Broken-hearted, Miss Lobb lived long enough to ensure May's writings and belongings were duly deposited in appropriate museums before dying less than a year after her beloved May.

Autumn and Winter
May Morris, n.d.

Margaret Burne-Jones
1866-1953

Edward Burne-Jones, second wave Pre-Raphaelite artist, adored his daughter Margaret. When she was a baby he nicknamed her 'Fatima' due to her chubby frame, and as she grew into a beautiful young woman he called her 'the brightest of bright things'. He claimed he took her breakfast in bed regularly and doted on her, wishing she would never grow up. He bought her a moonstone, which by superstition would keep the wearer at home by her father's side, never knowing love, never marrying.

Margaret grew up among writers and artists, her friends the children of other members of the Pre-Raphaelite circle. She went to school with May and Jenny Morris, daughters of William Morris, and she spent time with her cousin Rudyard Kipling and her brother Philip Burne-Jones, who would grow up to be an artist, less successful but as famous as his father. Many of her friends were the adults that came to visit her parents, and she allegedly received hundreds of love letters from John Ruskin, who was besotted with her. Another

visitor to the Burne-Jones household, Oscar Wilde, paid her attention, possibly hoping to curry favour with her father, writing a poem to her:

To M.B.J

Green are the summer meadows,
Blue is the summer sky,
And the swallows like flickering shadows
Over the tall corn fly.

And the red rose flames on the thicket,
And the red breast sings on the spray,
And the drowsy hum of the cricket
Comes from the new mown hay.

And the morning dewdrops glisten
And the lark is on the wing,
Ah! how can you stop and listen
To what I have to what I have to sing.

Margaret grew up under the scrutiny of her father, who increasingly used her as the epitome of his ideal beauty. She inherited her mother's tenacity but also her father's ability to dream, and did not mind posing for him, either in portraits or as Sleeping Beauty. However, as she

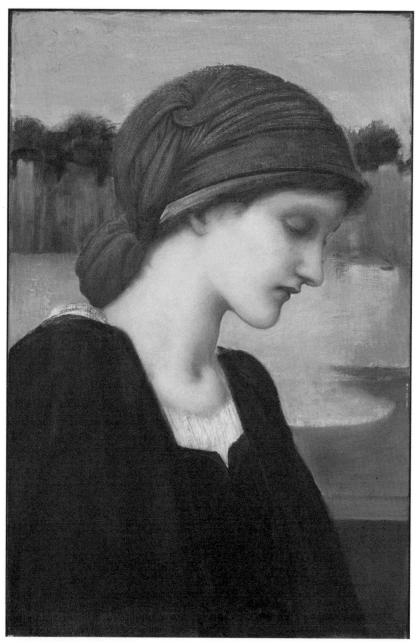

Flamma Vestalis
Edward Burne-Jones, c.1892

grew Margaret began to feel how tightly her father held on to her, complaining that his portraits made her look like a child when she wished to be a woman. Burne-Jones worried more and more about his daughter growing up and leaving him, showing her at the top of *The Golden Stairs* (1880) behind a crowd of her peers all descending the stairs and leaving through a door symbolising adulthood and marriage.

When Margaret married, it was to clever, handsome Scottish scholar, John William Mackail who had been a friend to Burne-Jones. Her father took the engagement as a betrayal. He wrote to friends of his anguish at his daughter deserting him and the worry made him ill. Despite his tantrums, Margaret and Jack lived close to him in London, and the family routine carried on much as it had been before, in time with the addition of grandchildren for Burne-Jones to dote on.

Margaret inherited her father's love of children and was well-known for her 'bad behaviour' meals at which

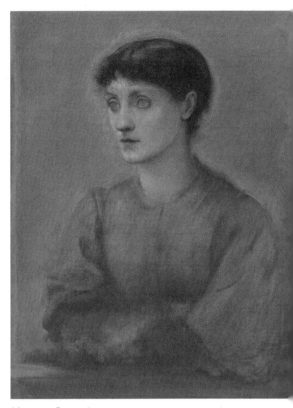

Margaret Burne-Jones
Edward Burne-Jones, c.1890

the children were allowed to do all the things that adults told them not to, such as talk with their mouths full and put their elbows on the table. She also wrote a brief biography of Mrs Beeton to go on the back of a postcard, but her life revolved mostly around her family. Both her daughter Angela Thirkell and son Denis Mackail became writers, as did Angela's son by her first marriage, Colin MacInnes.

HARRIET SELINA PETTIGREW

1867–1953

Harriet Pettigrew and her sisters were always famed for their temper as much as their beauty. Also known as 'Hetty' or 'Bessie', Miss Pettigrew started life in the less than glamorous surroundings of the side streets of Portsmouth. Hetty's father was a cork cutter and her mother worked as a seamstress when she wasn't tending to their thirteen children. Some of the sons had moved to London, a couple following their father's profession of cork cutting, and one dressed furs for sale. When their father died, the family was threatened with the workhouse; however one of Hetty's brothers had become friends with painters in London and thought his gorgeous sisters would be much in demand as models. How right he was, because the troublesome trio of Hetty, Lily and Rose were snapped up by some of the most famous artists of the century.

First of all they posed together for John Everett Millais' *An Idyll of 1745* (1884). Millais complained that the girls were never punctual and sometimes did not turn up at all, and soon they were known for their wilfulness as much as their beauty. As Millais' son recalled in his biography of his father, the Pettigrew girls gave him more trouble than any he had ever had to deal with. Describing them as 'three little gypsies', they came and went as it suited them, no matter what hours the artist stipulated.

Harriet Selina Pettigrew
Edward Linley Sambourne, c.1890

Edward Burne-Jones complained to James Abbott McNeill Whistler that Lily had left him stranded in the middle of a painting and if there was any justice in England she should be boiled alive. They also charged more than other models and Hetty wasn't afraid to shame any artist who dared to suggest they weren't worth it. When Whistler complained that half a guinea a day was too expensive, Hetty snapped back 'I'm so sorry, I'd quite forgotten you were one of the seven and sixpenny men,' which amused him no end and he paid what they demanded.

Hetty's sharp wit and intelligence made her more than the average model and she became a close companion to the artist Théodore Roussel, who taught her art and sculpture while she worked as his studio assistant. She posed in one of his most famous paintings, *The Reading Girl* (1886–7), which was also one of his most controversial, as it was a nude portrait of a woman without any excuse of mythology or classicism. The critics declared it to be vulgar, but Hetty and Roussel remained defiant. Hetty believed they would eventually marry, and

Hetty (l) and Lily Pettigrew
Edward Linley Sambourne, 1891

Hetty (l) and Lily Pettigrew
Edward Linley Sambourne, 1891

gave birth to the couple's child, Iris, in 1900. However, he married the widow of a fellow painter, so Hetty took her daughter and set up house with her sisters and mother in a home of their own, where she worked as a sculptor, supporting her family.

The Reading Girl
Théodore Roussel, 1886-7

The Pettigrew sisters made their money and lived out their lives in comfort. Both Rose and Lily married well, and Rose wrote about her sisters' adventures as models in a memoir published in 1947. Hetty never married, but raised Iris on her own, dying in 1953.

Overleaf – *An Idyll of 1745*
John Everett Millais, 1884

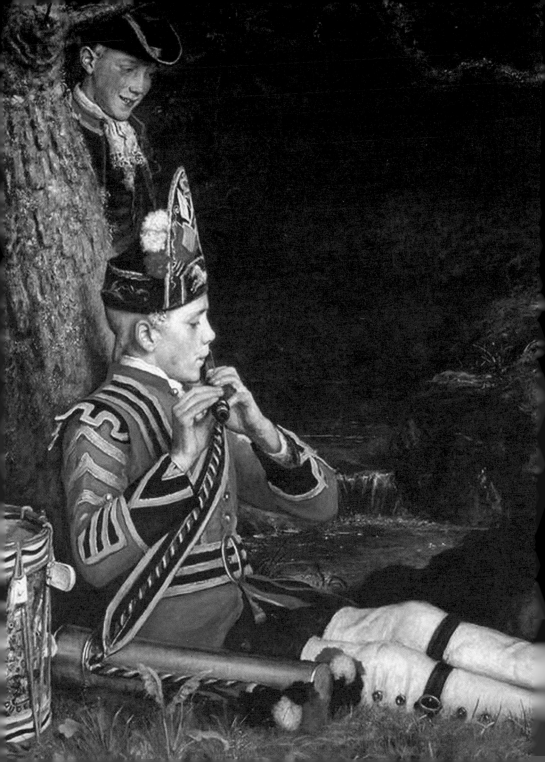

ELEANOR FORTESCUE-BRICKDALE

By the time Eleanor Fortescue-Brickdale started painting, many of the original Pre-Raphaelite Brotherhood had died, but she took inspiration from their art to forge her own golden path into the twentieth century. The daughter of barrister Matthew Ingett Fortescue-Brickdale, Eleanor was influenced by her much older brother, Charles, who was taught at John Ruskin's school of drawing. Being the baby in the family meant that she benefitted from her older siblings and their spouses when it came to artistic opportunities. Charles ultimately ran the newly established Land Registry office and asked his baby sister to create its first certificate in 1898. It took Eleanor three attempts to be accepted into the Royal Academy but her persistence paid off. She finally attended the Royal Academy school in 1896, but her faltering start may also have been due to her father's accidental death in Switzerland in 1894, when he fell down into a precipice whilst trying to get a good view of the scenery and was killed instantly. Despite this, Eleanor applied herself and won £40 in a competition to design a public building, with a lunette entitled *Spring*, which then hung in the Royal Academy dining room. The prize money enabled her to

Illustration for *'The Princess'* in Tennyson's *'Poems'*
Eleanor Fortescue Brickdale, 1907

The Pale Complexion of True Love
Eleanor Fortescue Brickdale, 1898

paint her first major oil painting, *The Pale Complexion of True Love* (1898), which remains one of her best-known works.

By 1901, Eleanor was confident enough to hold one-woman shows in galleries, never blind to the fact that since the death of her father she needed to support herself in her endeavours. In 1902, she became the first female member of the Royal Institute of Painters in Oils. She continued to study and was taught by John Byam Liston Shaw, with whom she developed a close and life-long friendship. When Shaw founded his own art school in 1911, Eleanor went to work for him and designed the logo for the school. Her painting *Ariel and Prospero* was unveiled in the board room of the BBC Broadcasting House in 1931.

Opposite – Illustration of Joan of Arc, from *The Golden Book of Famous Women*
Eleanor Fortescue-Brickdale, 1919

She is probably most famous for her book illustrations, producing richly illustrated editions of poems by Tennyson and Robert Browning, and gift books of stories for children. In 1919 she produced *The Golden Book of Famous Women*, a celebration of historical women, both real and fictional, with her beautiful watercolours of the women decorating the stories of these heroines. Each time she produced an illustrated book, she held an exhibition of the original works in a gallery, ensuring that even as an illustrator she was never underestimated as an artist.

After World War I, Eleanor was commissioned to design stained-glass windows in memory of those who had died, including ones at Bristol Cathedral (1927) and St Mary's, Taunton (1920). Eleanor signed her windows with an 'E', 'F' and a picture of a bee for 'B'. When her eyesight began to fail, she continued to design the windows, producing more than twenty until her retirement in 1940. As a committed Christian, Eleanor also donated pieces of her work to churches, echoing the religious concerns of the first generation of Pre-Raphaelite artists. She remained unmarried, living with

Prospero and Ariel
Eleanor Fortescue-Brickdale, 1931

her equally independent sister, Kate, after her mother died. She was one of the last great Victorian artists whose career had spanned both nineteenth and twentieth centuries, from Queen Victoria's death to World War II and yet, somehow, her artistic vision had never wavered from her Pre Raphaelite roots.

Opposite – *The Gilded Apple*
Eleanor Fortescue-Brickdale, 1899

May Louise Greville Cooksey

1878-1943

May Louise Greville Cooksey was born in Birmingham on 7 November 1878, the eldest of five children. Her father, Harry Smith Cooksey, had been an agent for Mansell Brewery

but set up his own removals and storage business, first of all in a pub and then in its own premises. Harry came from Southampton originally, but his parents had moved to Tuffley in Gloucestershire when he and his siblings were young and there he met his wife Catherine. His success in business is all the more remarkable when you take into account that Harry was visually impaired to the point that it was recorded on the census

The Marriage of St Catherine
May Cooksey, 1902

in 1891. It was possibly a hereditary condition because May's younger sister, Edith, was recorded as having impaired sight.

May showed promise as an artist from a young age, attending the Leamington School of Art from the age of thirteen, graduating four years later with First Class certificates and many prizes. In 1896, she moved to the Liverpool School of Art, winning further certificates and prizes, and her work was so admired that the local newspaper acquired one of her paintings to reproduce for their readers.

Her work was praised for being 'vigorous' and well-coloured, and she excelled in flower and portrait paintings in a late Pre-Raphaelite style, reminiscent of Eleanor Fortescue-Brickdale. Her often medieval women were painted in dark jewelled palettes, with flowers and natural adornments.

230

Religious Procession
May Cooksey, 1908

View from a Cloister
May Cooksey, 1902

of oils on The Stations of the Cross for Our Lady of Mount Carmel Roman Catholic Church and Presbytery in Liverpool in 1928, which are still on display today. In 1901, May received a Liverpool City Travelling Scholarship which meant she could travel to Italy and paint. She became a member of the Liverpool Academy of Arts, living at 1 Bold Place, St Luke's Chambers, Liverpool, then moving to Crosby in Lancashire, where she died in 1943.

Of all the women in the book, May Cooksey is undoubtedly the most unknown and whose promise as a young woman starting her career in art never resulted in deserved fame. I suspect her story is not unique and, in fact, there a lot more unknown and unappreciated female artists whose careers were seen as inferior to their male counterparts, or models who were seen as merely incidental to the art they inspired. By including them and celebrating them, we pave the way for rediscoveries and reassessment of what it meant to be a woman in the Pre-Raphaelite art world.

In 1899, at the age of twenty, May converted to the Catholic faith, and was baptised at St Francis Xavier's in Liverpool. She produced a series

Opposite – *Maria Virgo*
May Cooksey, 1915

MARIA·VIRGO

NOEL LAURA NISBET
1887-1956

Noel Laura Nisbet was born into an artistic family, enabled to follow her dreams by her father, Hume Nisbet's generosity. He was the son of a painter and decorator, James Herkis Nisbet who, with a sense of adventure, took his family from England to a new life in Australia. As a young man, Hume Nisbet was a creative soul, travelling around Australia on his own and trying out various careers, including acting and painting, which interested him so much that after his return to Britain in 1872, he found work as an art master in the School of Art in Edinburgh. It was there he met Helen Currie, the daughter of famed sculptor Andrew Currie, and married her.

With such a background in the arts, it's unsurprising that Noel and her sister Margaret Henrietta both became successful painters. Noel studied at Clapham School of Art, winning three gold medals, bronze medals and the Princess of Wales scholarship for her art. She also met artist Harry Bush at the Regent Street Polytechnic and married him in 1910. The head of the Clapham School of Art offered the couple free tuition to the school and the right to come and go as they pleased but sadly the Great War arrived and Harry was called away for service.

Noel and baby daughter Hazel spent World War I in Bath Cottage in Speen while Harry was away. On Harry's return, Hume Nisbet bought his artist daughters two matching

Self Portrait
Noel Laura Nesbit, n.d.

houses in Merton Park, now Old Merton Park, near Wimbledon. Both Noel and Margaret's houses had artist's studios in the attic space, and Noel, Harry and their children spent the rest of their lives there.

Noel exhibited in the 1914 Royal Academy, then another twenty-three times between 1914 and 1938. She was elected to the Royal Institute of Painters in Watercolour in 1926 and the Royal Watercolour Society in 1945. She also provided beautiful fairy-tale illustrations for books and her work can be seen as an extension of what Eleanor Fortescue-Brickdale had been doing earlier in the century. Often referred to as 'the last Pre-Raphaelite', her figures are reminiscent of both Edward Burne-Jones and Dante Gabriel Rossetti, in resplendent, florid clothes.

Noel and Harry lived out their days in the comfortable house in Merton Park with their daughters Hazel and Janet. Margaret, her sister, remained at the other end of the road, never married, and died only six years before her sister, in 1950.

The True Love
Noel Laura Nisbet, n.d.

The Mandex

HENRY WADSWORTH LONGFELLOW 1807 – 1882 ▶

American poet and Harvard professor, whose trade-mark long beard was grown to cover the burn scars he had sustained when attempting to save his wife when her dress caught fire.

Mentioned in the life of Mary Seton Watts.

◀ ALFRED TENNYSON 1809 – 1892

Poet Laureate for Queen Victoria, for which Tennyson was created 1st Baron Tennyson in 1883 after refusing the honour twice before. His early poetry, such as 'The Lady of Shalott' was a major influence of the Pre-Raphaelite artists, especially his friend and neighbour Julia Margaret Cameron.

Mentioned in the lives of Julia Margaret Cameron, Elizabeth Siddal, Ellen Terry, Mary Hillier, Mary Ryan, May Prinsep, Eleanor Fortescue-Brickdale.

WILLIAM BELL SCOTT 1811 – 1890 ▶

Artist, poet and friend of Dante Gabriel Rossetti, Bell Scott shared many reminiscences of bohemian life of indeterminate truthfulness.

Mentioned in the lives of Ruth Herbert, Fanny Cornforth.

◀ CHARLES DICKENS 1812 – 1870

Possibly the best known author of the nineteenth century, and father of Kate Perugini, Charles Dickens was initially a harsh critic of the Pre-Raphaelite artists and their choice of models but eventually counted many of them as his friends.

Mentioned in the lives of Mary Hodgkinson, Emma Watkins, Kate Perugini.

◄ ROBERT BROWNING 1812 – 1889

Poet and playwright, now best known for his marriage to
fellow poet Elizabeth Barrett Browning.
Mentioned in the life of Eleanor Fortescue-Brickdale.

OSCAR REJLANDER 1813 – 1875 ►

Swedish-born nineteenth century art-
photography pioneer, Rejlander travelled to England in 1839
as a bookkeeper, but gave it up to become first an artist, then
a photographer.
Mentioned in the lives of Julia Margaret Cameron, Mary Ryan.

HARRY HALL 1814 – 1882

The most famous equine portraitist of his generation, Hall
became the chief artist at *The Field*.
Mentioned in the life of Rosa Corder.

◄ GEORGE FREDERICK WATTS 1817 – 1904

One of the most prestigious artists of the Victorian
era, Watts spent much of his life in the household of
the Prinsep family, next door to Lord Leighton, at the
epicentre of artistic society in mid-Victorian Britain.
*Mentioned in the lives of Julia Margaret Cameron, Ruth
Herbert, Ellen Terry, Mary Hillier, Mary Seton Watts, May
Prinsep, Dorothy Dene.*

JOHN RUSKIN 1819 – 1900 ►

Leading art critic and writer of the nineteenth century,
Ruskin's marriage scandal caused him to withdraw his
support from John Everett Millais and offer his patronage
to Elizabeth Siddal. Conversely thoughtful and arrogant, he
remains one of the most contentious figures of the Pre-
Raphaelite movement.
*Mentioned in the lives of Mary Hodgkinson, Euphemia Gray,
Anna Blunden, Rosa Brett, Georgiana Burne-Jones, Sophia Gray,
Margaret Burne-Jones.*

FORD MADOX BROWN 1821 – 1893

French-born British artist, Brown provided mentoring and friendship to Dante Gabriel Rossetti. While never officially a member of the Pre-Raphaelite Brotherhood, his work reflected the subjects and style of the movement.

Mentioned in the lives of Emma Madox Brown, Christina Rossetti, Georgiana Burne-Jones, Lucy Madox Brown, Marie Spartali Stillman.

HENRY MERRITT 1822 – 1877

Art critic and picture conservator, Merritt's writings were published posthumously by his wife Anna, with her own illustrations.

Mentioned in the life of Anna Lea Merritt.

JAMES COLLINSON 1825 – 1881

Deeply religious member of the Pre-Raphaelite Brotherhood, Collinson converted from Catholicism to Anglicanism for Christina Rossetti, who still didn't want to marry him. After the controversy over Millais religious paintings, Collinson resigned, worried that the Brothers were bringing religion into disrepute.

Mentioned in the life of Christina Rossetti.

THOMAS WOOLNER 1825 – 1892

Sculptor and poet, Woolner was a founder member of the Pre-Raphaelite Brotherhood who went to Australia, possibly providing the inspiration for Ford Madox Brown's painting *The Last of England* (1855). He returned and married Alice Waugh, sister of Fanny and Edith.

Mentioned in the lives of Fanny and Edith Waugh, Julia Prinsep Jackson.

◀ GEORGE PRICE BOYCE 1826 – 1897

Artist Boyce kept a diary that provides a unique insight into the lives of many of the women who modelled for the Pre-Raphaelites. He was a particularly close friend of Rossetti, he bought many paintings of the models he also used, including works by his sister.

Mentioned in the lives of Joanna Boyce, Annie Miller, Ellen Smith.

WALTER DEVERELL 1827 – 1854

Friend of Dante Gabriel Rossetti, Deverell 'discovered' Elizabeth Siddal while she was working in Mrs Tozer's hat shop and asked her to model for his painting *Twelfth Night* (c.1850). He died at twenty seven of Bright's disease.
Mentioned in the lives of Mary Hodgkinson, Elizabeth Siddal.

FREDERIC GEORGE STEPHENS 1827 – 1907

One of the original seven Pre-Raphaelite Brothers, Stephens started his career as an artist but found the process too difficult so turned to criticism, loyally supporting the works of art of other Pre-Raphaelite painters.
Mentioned in the life of Mary Hodgkinson.

◄ WILLIAM HOLMAN HUNT 1827 – 1910

Founder member of the Pre-Raphaelite Brotherhood, Hunt stayed true to the tenets of Pre-Raphaelitism for the whole of his painting career, unlike the other members. Famously a little unhinged at times, his nickname was 'Maniac'.
Mentioned in the lives of Anna Blunden, Emma Watkins, Fanny and Edith Waugh, Annie Miller, Anna Lea Merritt, Julia Prinsep Jackson.

CHARLES ALLSTON COLLINS 1828 – 1873

Painter associated with the Pre-Raphaelite Brotherhood, Collins was the younger brother of novelist Wilkie Collins. Fell in love with Maria Rossetti, but married Kate Dickens.
Mentioned in the life of Kate Perugini.

DANTE GABRIEL ROSSETTI 1828 – 1882 ►

Founder member of the Pre-Raphaelite Brotherhood, Rossetti was known equally as a poet and a painter in his lifetime, but now we just tend to think of him as a bohemian womaniser who painted glorious portraits of the women with whom he was obsessed.
Mentioned in the lives of Mary Hodgkinson , Elizabeth Siddal, Emma Madox Brown, Christina Rossetti, Ruth Herbert, Aglaia Ionides, Annie Miller, Fanny Cornforth, Fanny Eaton, Jane Morris, Lucy Madox Brown, Marie Spartali Stillman, Ellen Smith, Alexa Wilding, Keytumas Gray, Rosa Corder, Kate Bunce, May Morris, Noel Laura Nisbet.

WILLIAM STILLMAN 1828 – 1901

American writer, war correspondent and photographer who married Marie Spartali after his first wife committed suicide.
Mentioned in the lives of Marie Spartali Stillman.

◄ HENRY TANWORTH WELLS 1828 – 1903

Artist, miniaturist, and friend to the Pre-Raphaelites through his wife Joanna Boyce.
Mentioned in the life of Joanna Boyce.

JOHN EVERETT MILLAIS 1829 – 1896 ►

The most successful of the Pre-Raphaelite Brotherhood, Millais found great financial success later in life with paintings of children and portraits of the great and the good. For his contribution to art he became the President of the Royal Academy and a baronet shortly before his death in 1896.
Mentioned in the lives of Mary Hodgkinson, Euphemia Gray, Elizabeth Siddal, Emma Watkins, Annie Miller, Fanny Eaton, Kate Perugini, Emma Sandys, Louise Jopling, Sophia Gray, Lillie Langtry, Dorothy Dene, Harriet Pettigrew.

FREDERICK SANDYS 1829 – 1904

Son of painter Anthony Sands, Sandys's embrace of the bohemian, Pre-Raphaelite lifestyle included a very complicated personal life which resulted in many children.
Mentioned in the lives of Fanny Eaton, Emma Sandys, Mary Sandys, Keytumas Gray, Rosa Corder.

◄ WILLIAM MICHAEL ROSSETTI 1829 – 1919

Brother to Dante Gabriel and Christina Rossetti, writer and critic William Michael was one of the seven original members of the Pre-Raphaelite Brotherhood.
Mentioned in the lives of Mary Hodgkinson, Emma Madox Brown, Christina Rossetti, Fanny and Edith Waugh, Fanny Cornforth, Lucy Madox Brown.

JOHN RODDAM SPENCER STANHOPE 1829 – 1908

Artist associated with the second-wave of the Pre-Raphaelite movement, Stanhope was the uncle of Evelyn de Morgan and had a studio in the rooms above Rossetti in Chatham Place, London.
Mentioned in the life of Ellen Smith.

◄ FREDERIC LEIGHTON 1830 – 1896

Artist famous for classical scenes of beauty, Leighton's mysterious love life tends to overshadow his High Victorian art legacy.
Mentioned in the life of Dorothy Dene.

JOHN BRETT 1831 – 1902

A landscape artist associated with the Pre-Raphaelite Brotherhood, John Brett unsuccessfully courted Christina Rossetti and overshadowed the career of his sister, Rosa.
Mentioned in the lives of Rosa Brett, Christina Rossetti.

LEWIS CARROLL 1832 – 1898 ►

Charles Lutwidge Dodgson, better known as novelist and photographer Lewis Carroll, found fame for his children's stories *Alice's Adventures in Wonderland* and *Through the Looking Glass*. He also obsessively collected photographic images of children, many of which he took himself, which has led to his reputation being tainted.
Mentioned in the lives of Julia Margaret Cameron, Christina Rossetti, Alice Liddell.

◄ EDWARD BURNE–JONES 1833 – 1898

Artist associated with the second-wave of Pre-Raphaelite art. Close friend of William Morris and leading proponent in the Aesthetic movement.
Mentioned in the lives of Ruth Herbert, Aglaia Ionides, Jane Morris, Georgiana Burne-Jones, Louise Jopling, Maria Zambaco, Marie Spartali Stillman, Ellen Smith, Mary Sandys, Julia Prinsep Jackson, Evelyn de Morgan, Kate Bunce, Violet Manners, Margaret Burne-Jones, Harriet Pettigrew, Noel Laura Nisbet.

GEORGE DU MAURIER 1834 – 1896 ▶

Cartoonist for *Punch* magazine and novelist, Du Maurier is probably best known these days as the grandfather of Daphne Du Maurier. His novel Trilby (1894), the story of an artist's model who becomes a star under the evil influence of Svengali was the inspiration for Gaston Leroux's 1910 novel *The Phantom of the Opera*.
Mentioned in the life of Aglaia Ionides, Maria Zambaco.

◀ WILLIAM MORRIS 1834 – 1896

Designer, poet and political activist, involved with the second-wave of Pre-Raphaelitism.
Mentioned in the lives of Jane Morris, Georgiana Burne-Jones, Lucy Madox Brown, Kate Bunce, May Morris, Margaret Burne-Jones.

JAMES ABBOTT MCNEILL WHISTLER 1834 – 1903 ▶

American-born artist who became a leading aesthetic artist and neighbour to Rossetti in Chelsea. He fought a libel case against John Ruskin, who accused him of 'flinging a pot of paint in the public's face' by moving towards abstraction.
Mentioned in the lives of Louise Jopling, Anna Lea Merritt, Mary Sandys, Rosa Corder, Harriet Pettigrew.

LAWRENCE ALMA-TADEMA 1836 – 1912

Dutch classical painter who moved to London after the death of his wife in 1869. He met his second wife, artist Laura Epps, in the home of Ford Madox Brown. His daughter Anna became a painter.
Mentioned in the life of Aglaia Ionides.

◀ EDWARD POYNTER 1836 – 1919

Painter and designer who was President of the Royal Academy.
Mentioned in the lives of Georgiana Burne-Jones, Ellen Smith, Mary Seton Watts, Evelyn de Morgan.

LOCKWOOD KIPLING 1837 – 1911

Illustrator and art teacher who taught in British India and brought traditional colonial art practices back to England. He illustrated works by his son Rudyard, and decorated the Dubar Room at Osborne House.
Mentioned in the lives of Georgiana Burne-Jones.

VAL PRINSEP 1838 – 1904

Pre-Raphaelite artist and member of the Prinsep family of Little Holland House, a cultural hub for mid-nineteenth century Pre-Raphaelite life.
Mentioned in the lives of Ruth Herbert, Kate Perugini, May Prinsep.

WILLIAM DE MORGAN 1839 – 1917

Ceramicist De Morgan worked for lifelong friend William Morris's company Morris & Co, designing tiles, stained glass and furniture. In his lifetime he was better known for his novels which are all but forgotten now.
Mentioned in the life of Evelyn de Morgan.

CHARLES PERUGINI 1839 – 1918

Italian-born romantic painter, brought to England by Lord Leighton to work in his studio. After Charles Collins died, Perugini married Kate Dickens.
Mentioned in the life of Kate Perugini.

◄ CHARLES AUGUSTUS HOWELL 1840 – 1890

Aristocrat, Buccaneer, art dealer and inveterate liar, Howell enabled the exhumation of Elizabeth Siddal and the forgery of many works of art.
Mentioned in the life of Rosa Corder.

SIMEON SOLOMON 1840 – 1905

Pre-Raphaelite painter from an artistic family, Solomon is best known for his depictions of Jewish religious life and same-sex love. His close association with the bohemian society was cut short after his arrest for lewd acts in a public urinal just off Oxford Street. The workhouse and alcoholism both contributed to deterioration in his abilities in the last years of his life.
Mentioned in the lives of Fanny Eaton, Ellen Smith.

SAMUEL JNR BANCROFT 1840 – 1915

American industrialist and Pre-Raphaelite enthusiast whose collection formed the basis of the Delaware Art Museum.
Mentioned in the life of Fanny Cornforth.

◄ AUGUSTE RODIN 1840 – 1917

French sculptor, most famous for *The Kiss* (1889) and *The Thinker* (1879-89).
Mentioned in the life of Maria Zambaco.

WILFRID SCAWEN BLUNT 1840 – 1922

Political activitist, writer, horse breeder and libertine, Blunt recorded his conquests in his memoirs.
Mentioned in the life of Jane Morris.

ALBERT MOORE 1841 – 1893

Aesthetic painter from a large artistic family from York. Best known for his many images of languid, draped women looking pensive in pale, classical surroundings.
Mentioned in the life of Fanny Eaton.

THEODORE ROUSSEL 1847 – 1926 ►

French-born artist based in London, Roussel changed careers from the military to art in his mid-twenties, after teaching himself to paint.
Mentioned in the life of Harriet Pettigrew.

JOSEPH SWYNNERTON 1848 – 1910

Manx sculptor from a large family of artists, many of whom were sculptors, including his father.
Mentioned in the life of Annie Louisa Swynnerton.

JOHN COLLIER 1850 – 1934

Artist who painted in the Pre-Raphaelite style and painted many portraits including both the granddaughter and nephew of Georgiana Burne-Jones.
Mentioned in the life of Anna Lea Merritt.

FRANK MILES 1852 – 1891

Artist in chief at *Life Magazine* and friend of Oscar Wilde, Miles was a society portraitist as well as a keen plant lover. His confinement to an asylum has led to him becoming a Jack the Ripper suspect.

Mentioned in the life of Lillie Langtry.

◄ OSCAR WILDE 1854 – 1900

Anglo-Irish poet and playwright, Wilde was a personality, known for his quotable wit, love of aestheticism and open defence of homosexuality which ended his career after he was imprisoned.

Mentioned in the lives of Louise Jopling, Maria Zambaco, Anna Lea Merritt, Lillie Langtry, Margaret Burne-Jones.

JOHN SINGER SARGENT 1856 – 1925 ►

American-born artist and leading portraitist of his generation.

Mentioned in the lives of Anna Lea Merritt, Ellen Terry.

◄ GEORGE BERNARD SHAW 1856 – 1950

Playwright, critic, political writer and vegetarian, Shaw apparently used the transformation of at least two artists's models into ladies as the inspiration for his play Pygmalion (1912).

Mentioned in the lives of Jane Morris, May Morris.

PHILIP BURNE-JONES 1861 – 1926

Eldest son of Georgiana Burne-Jones, Burne-Jones succeeded to the title of baronet which his father had accepted just so his son could have that advantage. Despite being a painter like his father, Philip Burne-Jones could not find the same level of respect and success.

Mentioned in the life of Margaret Burne-Jones.

RUDYARD KIPLING 1865 – 1936

Writer, famous for tales of colony and empire, Kipling spent many years living close to his aunt, Georgiana Burne-Jones in West Sussex.

Mentioned in the lives of Georgiana Burne-Jones, Margaret Burne-Jones.

JOHN BYAM LISTON SHAW 1872 – 1919

Painter and illustrator who turned to teaching when his art slipped from fashion, founding the Byam Shaw School of Art.
Mentioned in the life of Eleanor Fortescue-Brickdale.

ALFRED MUNNINGS 1878 – 1959

Artist, particularly well known for his paintings of horses and the Romany community, Munnings was a war artist who could not bring himself to embrace Modernism.
Mentioned in the life of Keytumas Gray.

HARRY BUSH 1883 – 1957

Artist, best known for his depictions of suburban modern life, often as viewed from his studio window in the Greater London borough of Merton.
Mentioned in the life of Noel Laura Nisbet.

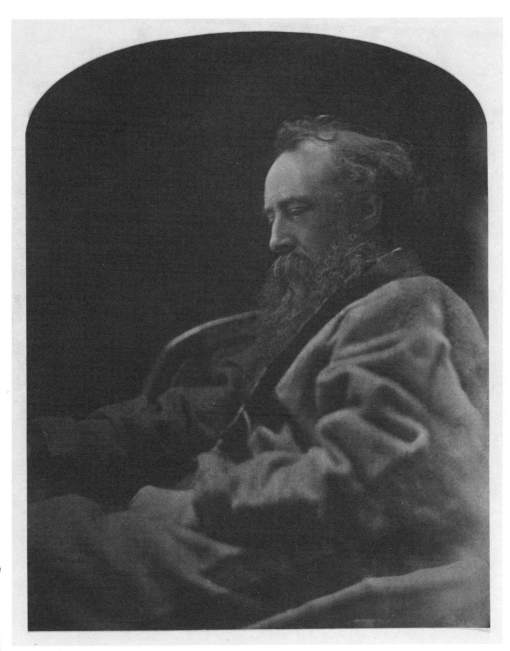

George Frederick Watts
Julia Margaret Cameron, 1864

Further Reading

GENERAL

The Pre-Raphaelites: Their Lives and Works in 500 Images: An Illustrated Exploration of the Artists, Their Lives and Contexts, with a Gallery of 290 of Their Greatest Paintings (2012) Michael Robinson

The Pre-Raphaelites (1970) Timothy Hilton

Pre-Raphaelites (1998) Tim Barringer

Victorian Painting (2003) Lionel Lambourne

Victorian Art World in Photographs (1984) Jeremy Maas

PRE-RAPHAELITE WOMEN

Pre-Raphaelite Sisterhood (1985) Jan Marsh

Pre-Raphaelite Women: Images of Femininity in Pre-Raphaelite Art (1989) Jan Marsh

Pre-Raphaelite Women Artists (1999) Jan Marsh and Pamela Gerrish Nunn

Women Artists and the Pre-Raphaelite Movement (1989) Jan Marsh and Pamela Gerrish Nunn

BOOKS ON THE INDIVIDUAL WOMEN

Jane Morris: The Pre-Raphaelite Model of Beauty (2000) Debra N. Mancoff

Jane and May Morris: A Biographical Story, 1839-1938 (1986) Jan Marsh

May Morris: Arts & Crafts Designer (2017) Anna Mason and Jan Marsh

Christina Rossetti: A Literary Biography (1994) Jan Marsh

The Legend of Elizabeth Siddal (1992) Jan Marsh

Lizzie Siddal: The Tragedy of a Pre-Raphaelite Supermodel (2004) Lucinda Hawksley

Elizabeth Siddal 1829-1862: Pre-Raphaelite Artist (1991) Jan Marsh

My Grandmothers and I (1960) Diana Holman Hunt

My Grandfather, His Wives and Loves (1969) Dian Holman Hunt

The Actress and the Brewer's Wife: Two Victorian Vignettes (1997) Virginia Surtees

Sublime & Instructive: Letter from John Ruskin to Louisa, Marchioness of Waterford, Anna Blunden and Ellen Heaton (1972) Virginia Surtees

The Making of Mary Seton Watts (2013) Mary McMahon

Stunner: The Rise and Fall of Fanny Cornforth (2006) Kirsty Stonell Walker

A Pre-Raphaelite Journey: The Art of Eleanor Fortescue-Brickdale (2012) Pamela Gerrish Nunn

Joanna, George, and Henry: A Pre-Raphaelite Tale of Art, Love and Friendship (2012) Sue Bradbury

A Circle of Sisters: Alice Kipling, Georgiana Burne-Jones, Agnes Poynter and Louisa Baldwin (2002) Judith Flanders

Julia Margaret Cameron: 19th Century Photographer of Genius (2003) Colin Ford

Julia Margaret Cameron's Women (1998) Sylvia Wolf

Lillie Langtry: Manners, Masks and Morals (1999) Laura Beatty

The Story of my Life (1908) Ellen Terry

Katey: The life and Loves of Dickens' Artist Daughter (2006) Lucinda Hawksley

Effie: The Passionate Lives of Effie Gray, John Ruskin and John Everett Millais (2012) Suzanne Fagence Cooper

Poetry in Beauty: The Pre-Raphaelite Art of Marie Spartali Stillman (2015) Margaretta S Frederick and Jan Marsh

The Real Alice in Wonderland: A Role Model for the Ages (2010) C M Rubin and Gabriella Rose Rubin

Love Locked Out: The Memoirs of Anna Lea Merritt (1982) Anna Lea Merritt

Unquiet Souls: Indian Summer of the British Aristocracy (1985) Angela Lambert

The Souls (1985) Jane Abdy

The Life and Works of Annie Louisa Swynnerton (2018) Susan Thomson

IMAGE CREDITS

p.9 World History Archive / Alamy Stock Photo; p.10 Metropolitan Museum of Art, David Hunter McAlpin Fund, 1952; p.12 courtesy of Wikimedia Commons, scanned from Colin Ford's Julia Margaret Cameron: 19th Century Photographer of Genius, ISBN 1855145065. Originally from Royal Photographic Society; p.13 Metropolitan Museum of Art, Alfred Stieglitz Collection, 1949; Metropolitan Museum of Art, Harris Brisbane Dick Fund, 1941; p.17 Art Collection 4 / Alamy Stock Photo; p.18 World History Archive / Alamy Stock Photo; p.22 The National Trust Photolibrary / Alamy Stock Photo; p.23 author's own; author's own; p.24 author's own; p.26 Sailko, courtesy of Wikimedia Commons; p.28 author's own; Johannesburg Art Gallery, courtesy of Wikimedia Commons, http://www.arte.it/foto/da-degas-a-picasso-i-capolavori-della-johannesburg-art-gallery-a-pavia-279/18; author's own; p.29 Delaware Art Museum, Samuel and Mary R. Bancroft Memorial, 1935, courtesy of Wikimedia Commons, http://www.preraph.org/images/artwork/large/1935-57.jpg; p.30 National Gallery of Canada, courtesy of Wikimedia Commons; p.32 author's own; p.33 courtesy of Wikimedia Commons, Treuherz, Julian (2011), Ford Madox Brown: Pre-Raphaelite Pioneer, p.249; p.34 Metropolitan Museum of Art, Rogers Fund, 1910; p.35 The Artchives / Alamy Stock Photo; p.38 Woolley and Wallis; p.39 Yale Center for British Art, Paul Mellon Fund; p.40 Artefact / Alamy Stock Photo; p.42 courtesy of Wikimedia Commons, QF2GMaDpQLM2w at Google Cultural Institute; www.reveriesunderthesignofausten.wordpress.com; p.43 www.reveriesunderthesignofausten.wordpress.com; p.44 courtesy of www.the-athenaeum.org; p.46 Metropolitan Museum of Art, Rogers Fund, 1921; private collection, courtesy of www.the-athenaeum.org; p.47 author's own; p.48 Art Collection 2 / Alamy Stock Photo; p.50 Sothebys, courtesy of Wikimedia Commons; p.51 author's own; p.52 private collection, courtesy of Wikimedia Commons; p.54 courtesy of Wikimedia Commons, http://www.tate.org.uk; p.55 the Picture Art Collection / Alamy Stock Photo; p.59 author's own; p.60 courtesy of www.the-athenaeum.org; p.62 courtesy of Wikimedia Commons, www.bg-gallery.ru/image.php?img_id=198; p.63 author's own; p.64 The Schaeffer Collection courtesy of Wikimedia Commons, http://rhapsodyinwords.com/?attachment_id=1920; p.65 courtesy of Wikimedia Commons, http://www.bg-blog.ru/comments.php?id=629; p.68 The Picture Art Collection / Alamy Stock Photo; p.69 The Picture Art Collection / Alamy Stock Photo; p.70 Christies, courtesy of Wikimedia Commons; p.72 private collection, courtesy of Wikimedia Commons; p.73 courtesy of Wikimedia Commons, Tate Gallery online database http://goldenagepaintings.blogspot.it/2008/12/dante-gabriel-rossetti-woman-in-yellow.html; p.76 Metropolitan Museum of Art, Rogers Fund, 1908; p.77 courtesy of Wikimedia Commons, scanned from Wildman, Stephen: Edward Burne-Jones: Victorian Artist-Dreamer, Metropolitan Museum of Art, 1998, ISBN 0870998595; p.78 courtesy of Wikimedia Commons, http://www.nationalmuseum.se/sv/Om-Nationalmuseum/For-press-och-media1/Pressbilder1/Prerafaeliterna/Dante-Gabriel-Rossetti-iFagra-Rosamund--Fair-Rosamundi; p.79 author's own; p.80 http://www.simeonsolomon.com/artwork-1856-1860.html, courtesy of curiator.com; p.82 Yale Center for British Art, Paul Mellon Fund; courtesy of wikiart.org; p.83 Archivart / Alamy Stock Photo; p.84 courtesy of Wikimedia Commons, The Yorck Project (2002) 10.000 Meisterwerke der Malerei (dvd-rom), distributed by Directmedia Publishing GmbH. ISBN: 3936122202; p.86 Birmingham Museum and Art Gallery, courtesy of Wikimedia Commons, rQF6j-bOe2n88Q at Google Cultural Institute; p.87 author's own; p.88 courtesy of Wikimedia Commons, http://www.rossettiarchive.org/zoom/sa140eee.img.htm; private collection, courtesy of www.the-athenaeum.org; p.89 J. Paul Getty Museum, open content programme; p.90 private collection, courtesy of www.the-athenaeum.org; p.92 courtesy of Wikimedia Commons; p.93 World History Archive / Alamy Stock Photo; p.94 author's own; p.96 private collection, courtesy of Wikimedia Commons; p.97 PAINTING / Alamy Stock Photo; p.98 courtesy of Wikimedia Commons, http://blog.aladdin.co.kr/panda78/546071; p.100 courtesy of Wikimedia Commons, repro from artbook; p.101 Metropolitan Museum of Art, The Alfred N. Punnett Endowment Fund, 1947; p.102 private collection, courtesy of Wikimedia Commons; p.104 courtesy of Wikimedia Commons, http://polarbearstale.blogspot.com/2010/06/emma-sandys-1843-1877.html; p.106 Historic Images / Alamy Stock Photo; courtesy of Wikimedia Commons, http://polarbearstale.blogspot.com/2010/06/emma-sandys-1843-1877.html; p.107 courtesy of Wikimedia Commons, http://store.encore-editions.

com/VART/svicartw110.html; p.108 private collection, courtesy of wikimedia commons; p.110 courtesy of Wikimedia Commons, http://www.gutenberg.org/files/39000/39000-h/39000-h.htm; p.111 Art Collection 2 / Alamy Stock Photo; p.112 courtesy of Wikimedia Commons, Treuherz, Julian (2011), Ford Madox Brown: Pre-Raphaelite Pioneer, London: Philip Wilson Publishers, ISBN 978-0-85667-700-7; p.114 private collection, courtesy of Wikimedia Commons; p.115 private collection, courtesy of Wikimedia Commons; p.116 courtesy of Wikimedia Commons, Millais exhibition catalogue; p.118 Christies, courtesy of Wikimedia Commons; p.119 author's own; p.120 courtesy of Wikimedia Commons; p.122 J. Paul Getty Museum, open content programme; p.123 private collection, courtesy of Wikimedia Commons; p.124 Ian Dagnall / Alamy Stock Photo; p.126 courtesy of wikinow.co; p.128 Sailko, courtesy of Wikimedia Commons; p.129 Historic Collection / Alamy Stock Photo; p.130 Art Collection 2 / Alamy Stock Photo; p.132 Harvard Art Museums/Fogg Museum, Bequest of Grenville L. Winthrop; private collection, courtesy of www.the-athenaeum.org; p.133 private collection, courtesy of Wikimedia Commons, Sothebys; p.134 courtesy of Wikimedia Commons, http://www.artmagick.com/pictures/picture.aspx?id=6587&name=the-young-mother; p.136 http://my-museum-of-art.blogspot.com/2010_12_26_archive.html; p.137 The History Collection / Alamy Stock Photo; p.138 Delaware Art Museum, Samuel and Mary R. Bancroft Memorial, 1935, courtesy of Wikimedia Commons, http://www.preraph.org/searchresults. php?rp=5&class=painting; p.140 Delaware Art Museum, Samuel and Mary R. Bancroft Memorial, 1935, courtesy of Wikimedia Commons, https://web.archive.org/web/20150114185251/http://www. preraph.org/searchresults.php?artist=Frederick+Sandys&class=; p.141 private collection, courtesy of Wikimedia Commons, Sothebys; p.142 Metropolitan Museum of Art, Purchase, Joseph Pulitzer Bequest, 1996; p.144 The Picture Art Collection / Alamy Stock Photo; p.145 courtesy of Wikimedia Commons, http://artuk.org/discover/artworks/julia-prinsep-stephen-nee-jackson-18461895-formerly-mrs-duckworth-29965; p.148 Harvard Art Museums/Fogg Museum, Bequest of Grenville L. Winthrop; p.149 author's own; p.150 Delaware Museum of Art, Samuel and Mary R. Bancroft Memorial, 1935, courtesy of Wikimedia Commons; p.151 Harvard Art Museums/Fogg Museum, Gift of Grenville L. Winthrop, Class of 1886; p.152 J. Paul Getty Museum, open content programme; p.154 courtesy of Wikimedia Commons, Photo: Andreas Praefcke; p.155 J. Paul Getty Museum, open content programme; Library of Congress, Prints & Photographs Division, [LC-DIG-ggbain-28992; p.156 J. Paul Getty Museum, open content programme; p.158 courtesy of Wikimedia Commons, scanned from Colin Ford's Julia Margaret Cameron: 19th Century Photographer of Genius, ISBN 1855145065. Originally from National Museum of Photography, Film & Television, Bradford; p.159 courtesy of Wikimedia Commons, scanned from Colin Ford's Julia Margaret Cameron: 19th Century Photographer of Genius, ISBN 1855145065. Originally from Royal Photographic Society; p.160 J. Paul Getty Museum, open content programme; p.162 Metropolitan Museum of Art, The Elisha Whittelsey Collection, The Elisha Whittelsey Fund, 1969; p.163 courtesy of Wikimedia Commons, scanned from Colin Ford's Julia Margaret Cameron: 19th Century Photographer of Genius, ISBN 1855145065. Originally from The Board of Trustees of the Victoria and Albert Museum, London; p.166 NMUIM / Alamy Stock Photo; p.167 courtesy of Wikimedia Commons; p.170 J. Paul Getty Museum, open content programme; p.171 courtesy of Wikimedia Commons, Wyrdlight at English Wikipedia; author's own; p.172 Metropolitan Museum of Art, Bequest of Maurice B. Sendak, 2012; p.174 J. Paul Getty Museum, open content programme; p.175 Metropolitan Museum of Art, Bequest of Maurice B. Sendak, 2012; p.178 J. Paul Getty Museum, open content programme; p.179 courtesy of Wikimedia Commons, http://goldenagepaintings.blogspot.com/2009/01/george-frank-miles.html; p.180 Metropolitan Museum of Art, David Hunter McAlpin Fund, 1952; p.182 J. Paul Getty Museum, open content programme; p.183 courtesy of Wikimedia Commons, scanned from Colin Ford's Julia Margaret Cameron: 19th Century Photographer of Genius, ISBN 1855145065. Originally from National Museum of Photography, Film & Television, Bradford; p.186 courtesy of Wikimedia Commons; p.187 courtesy of Wikimedia Commons; p.188 private collection, courtesy of www.the-athenaeum.org; p.190 courtesy of Wikimedia Commons, Evelyn de Morgan; p.192 Russell-Cotes Art Gallery & Museum, Bournemouth; p.194 private collection, courtesy of Wikimedia Commons, Sothebys; p.196 Archivart / Alamy Stock Photo; p.197 Archivart / Alamy Stock Photo; p.198 courtesy of Wikimedia Commons,

Kirsty Stonell Walker

It was while studying for her first degree that Kirsty Stonell Walker became immersed in the life and loves of the Pre-Raphaelites. The plight of 'bad girl' Fanny Cornforth fascinated her so much that she spent a decade researching her life and wrote her biography *Stunner: The Fall and Rise of Fanny Cornforth*. Since 2011, she has written a blog, *The Kissed Mouth*, where she publishes original research on the many models of the Pre-Raphaelites. She has also written two novels about Victorian artists as well as giving talks to art groups and museums on the subject.

Kingsley Nebechi

ILLUSTRATOR

Kingsley Nebechi is an Italian born, British raised illustrator. His work is inspired by his love for patterns, comics and fashion. Kingsley's artwork has been featured on book covers, ad campaigns, product packaging and animation. Kingsley was also included in Buzzfeed's *34 British Young Black Artists You Should Pay Attention to* in 2017.

First published by Unicorn
an imprint of Unicorn Publishing Group LLP, 2018
5 Newburgh Street
London W1F 7RG
www.unicornpublishing.org

10 9 8 7 6 5 4 3 2

ISBN 978-1-911604-63-1

Design: Felicity Price-Smith

Printed in India by Imprint Press